RUINED LANDSCAPES

RUINED

John F. Blair, Publisher
WINSTON-SALEM, NORTH CAROLINA

LANDSCAPES

Paintings of the Balkan War Zone

Paintings by Laura Buxton
Text by Ross Yockey
Foreword by Hugh L. McColl, Jr.

Published by John F. Blair, Publisher

*The paper in this book meets the guidelines for permanence and
durability of the Committee on Production Guidelines for
Book Longevity of the Council on Library Resources.*

Library of Congress Cataloging-in-Publication Data

Yockey, Ross.

Ruined landscapes : paintings of the Balkan War zone / paintings by Laura Buxton ;
text by Ross Yockey ; foreword by Hugh L. McColl, Jr.

p. cm.

Includes bibliographical references and index.

ISBN 0-89587-225-0 (alk. paper)

1. Buxton, Laura—Catalogs. 2. Yugoslav War, 1991–1995—Art and
the war—Catalogs.

3. McColl, Hugh L.—Art collections—Catalogs. 4. Art—Private collections—
Catalogs. I. Title.

N6797.B95 A4 2000

759.13—dc21 00-039788

Design by Debra Long Hampton

C ONTENTS

FOREWORD

A sketch of St. Peter's Catholic Church in Charlotte, North Carolina, peaceful, simple, and unremarkable—that was Laura Buxton's initial contribution to my collection, in 1989. *St. Peter's* was Laura's gift, her thank-you for lending her a car to drive while she was in town working as colorist for internationally famous fresco artist Ben Long, who was painting a triptych behind the altar at St. Peter's.

Ben and Laura returned to Charlotte in 1992. She was one of his associate artists on the monumental fresco for the lobby of the new corporate headquarters of our company, NationsBank, now Bank of America.

About four years after the completion of the bank fresco, Laura's American agent invited me to look at slides of some paintings she had been working on in the Balkans. It so happened that I was just then immersed in books about the First World War and had become intrigued by the Balkan transition from Ottoman Empire to Hapsburg rule. Looking at the slides, I was struck not only by their artistic merit but by their historical value as well. It seemed important that the group should be kept together, not broken up and sold to individual collectors. I immediately decided to buy whatever portion of the collection she had not already sold, despite having viewed only the slides.

Once the actual paintings were delivered, I realized I had made a good decision regarding both art and history.

Among the most dramatic works Laura completed in her two Balkan sojourns is a sepia of another St. Peter's Catholic Church, half a world away. That church seems rather like a skull crushed under the heel of war, although the title of the drawing is *Mir*, or "Peace." Extraordinarily rich in detail, powerful and evocative, *Mir* shows the stunning growth in scope and execution achieved by the artist in a short period of time.

As she worked, Laura inscribed the backs of many of the paintings, telling something about her subjects and the circumstances of her capturing them. The inscriptions are extraordinarily descriptive, and they, too, are worth preserving.

In order to let others appreciate the works, I sponsored several exhibits. It became clear that men and women from many different walks of life felt much as I did in the presence of these paintings; they are like ghosts, rattling the chains of war in the attic of our souls. At the exhibition in Washington, D.C., the Bosnian ambassador was moved to tears upon walking into the gallery.

Whether Laura Buxton's Balkan series is great art or simply tells a great story must be left to the critics. Of the paintings' documentary importance there can be no doubt. I am also certain they can be an inspiration to other artists, if only as an illustration of the value of hard work. The sheer effort that went into these paintings, in such a short period of time, is an extraordinary achievement in itself.

Much of the work that art museums display from centuries past was paid for by the church or was created for the aggrandizement of warrior kings and princes and paid for by the subjects in the paintings. All artists have done that sort of work to make a living. But the great ones also have given us a record of their times, painting ordinary people and scenes from life. When an artist can transmit his or her emotions about such times and people and scenes through pigment and brush strokes, we are made to share the same emotions many years after the fact. Mexican art, for example, is almost all social art; both the lumpy, muscular figures of downtrodden people struggling to overcome and the cantina gaiety, the escapism, move us in compelling ways. Perhaps the artists who give us serene landscapes and still lifes that express their love of nature are actually ecologists in disguise.

Laura Buxton is an artist with very strong social views. Yet she worries that what she does is "trivial," that it "doesn't really matter." As "merely an artist," Laura feels powerless. On the other hand, as the leader of one of the United States' largest financial institutions, I am often called powerful. Perhaps by making Laura's paintings available to a wider public through this book, I can transfer some of that so-called power to her work. Certainly, one reason I am sponsoring this book is

so that more people may become aware of Laura Buxton as an artist, because I greatly admire her work.

I also hope the book will serve as a wake-up call. The history of the Balkans is something most Americans simply pay no mind to. Europeans are more aware of it, but one wonders if they pay as much attention to it as they should. They seem too often to dismiss it as we in the United States slough off conflicts in Central America. The 1998–99 war in Kosovo showed us that we should have paid a good deal more attention to what happened in Bosnia-Herzegovina, and that we had better pay attention as it relates to Montenegro.

Laura Buxton's work demands a wider audience than it could receive as part of a private collection. Here is art about a great tragedy of our age, occurring after the Cold War, in peacetime, and not in the so-called Third World but in the heart of Europe. Perhaps this book will awaken us to the plight of people who are very much like ourselves and who are literally our neighbors, being no more than twelve hours away by air. United States bombers flew from Kansas to Kosovo, then back to their base in time for breakfast. I hope people will see the paintings as an admonition to try another policy.

Laura's paintings very graphically show the cost of war and its futility. The Balkan wars have destroyed objects of inestimable value, to no discernible gain. Will anybody be interested? I don't know.

I hope readers and art lovers will be struck by these paintings, that the book will make them think, maybe empathize, maybe help somehow. I know that's what Laura would like. She would like to show, through her curiously unpeopled paintings—an aspect that strikes me each time I look at them—the plight of a people and the extent of their suffering. Laura Buxton says she simply "would wish people to be affected by the paintings," that this is "the most one could hope for." My own hope is grander—that these paintings might actually awaken some of us and inspire us to work toward change.

A hundred years from now, someone may look at these works and say, "I'm glad Laura Buxton went there to paint. I'm glad we know something about how Bosnia looked in those days." As a collection, this is important documentary art. I've been given the resources to tell Laura's story, and thereby to tell the Balkan people's story as well. As for political statements, readers and art lovers must draw their own conclusions.

Hugh L. McColl, Jr.

RUINED LANDSCAPES

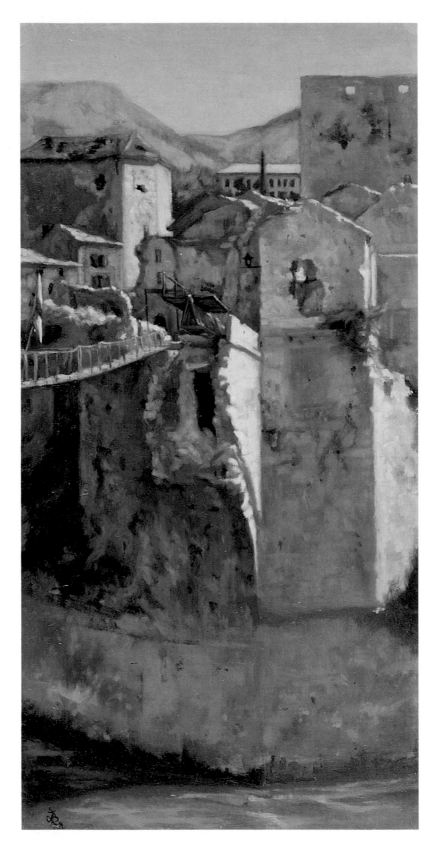

Figure 1
Stari Most
Oil

Part One

PUBLIC PLACES

On a slippery rock on the west bank of the river Neretva, minds swirling swift as the jade, icy currents below, visitors from America might easily lose their emotional footing.

It would be hard for such visitors to reconcile this scene with what they know of Europe, the Cold War done and the twentieth century come almost to its coda. Yet Europe it is. All the desperate, frightened people about only *seem* to be from some other continent, some other time. The otherworldliness rises not from the people but from their crumbling monuments, from their buildings, which had survived so many brutal centuries only to fall at the end of this one.

The people, in fact, are neighbors to Americans, and many of them have family in the United States, perhaps standing in supermarket lines. Some of them have friends in Paris, only eight hundred miles off, queuing up now for art museums and concerts. Some have friends waiting now on Rome's Via Veneto, less than three hundred miles from this green river rock, for fashion shows and favorite trattorias. Here, on either side of the Neretva, they queue for food handouts, for medical assistance, for permission to enter the part of the city where their homes used to be.

Unexpectedly but not surprisingly, from the hills near the old Orthodox church come the crack and echo of rifle shots. There is supposed to be a cease-fire, but there are too many guns and too little hope to keep the snipers quiet. The Muslims and Croats have formed a federation, yet the fighting between them continues. The Serbs want to control everything and have agreed to nothing. The American visitors can make little sense of the hostilities.

Nearby, an artist is at work, a woman who has looked into the faces on all these warring sides and can find little difference among them. Their eyes, their hair, their bone structure—the things an artist sees—permit no neat ethnic categorizing. Each person here speaks the same Slavic language. Each individual is a European, the product of thousands of years of civilization, since the time of cave-wall canvases. If she were a doctor, a sociologist, or a writer, this sensitive woman might study the people of Bosnia-Herzegovina and try to understand how they came to fashion such exclusive labels for themselves. But she is only an artist, spreading colors on a canvas.

To the American visitors, the human misery around the artist seems overwhelming. They wonder what could have brought an artist here, with her bundle of canvases and drawing pads, her brushes and paints and charcoals, her tidy little fold-down stool and easel. Obviously, the people here do not need artists, they need doctors to heal their wounds. They don't need their portraits painted, they need their crippled homes shored up. They need food. They need clean water. Even if the artist is able somehow to capture their pain in paint, that will not make things any better. Why doesn't she volunteer at the relief agency and make herself *useful*.

Then, looking up from the rock at the edge of the Neretva, the visitors notice a figure in the cliff wall, like the cloud figures a child's imagination fancies dancing across the sky. It is an enormous, anguished face of carved stone looming above the river froth, like a death's-head guarding some titan's tombstone. The face pushes out of the earth on the far bank, trapped, rooted in the torment of hell. Its empty eye sockets are sightless, its mouth soundlessly screaming, frantic to tell its story. A tower, a fingerless arm, flails the air above, summoning believers. Suddenly, the visitors understand what has drawn the artist to this spot.

❧

The artist, Laura Buxton, knows the death's-head's name: Stari Most. Exotic and evocative as that rings in ears used to English or French, the Slavic words mean simply "Old Bridge," nothing more. That is what it was until last November, simply a very old bridge. Only in recent months has it come to represent the torment of hell, and of war. This Stari Most has become the established symbol of Balkan misery. And Buxton's new Balkan friends have told her a bit of the bridge's long history. Stari Most went up in 1566. That

year, William Shakespeare was in his infancy, and Britain was twenty years from launching its first serious attempt to colonize North America. Those were the glory days of the Ottoman Empire, when Turkish sultans were determined to bring true civilization—the civilization of Islam—to the medieval villages of southern Europe. For the sultans, failure was not an option. Thus, when Emperor Suleiman the Magnificent decreed the building of a great bridge over the Neretva, he told his favorite architect, Mimar Hajredin, that if the bridge fell, so would Hajredin's head. The resulting design, a single arch with a span of nearly a hundred feet and a height of sixty feet, was a unique architectural accomplishment. It was a bridge built to withstand anything nature and all the armies of Christendom could hurl at it.

Around the bridge, on both sides of the copper-infused Neretva, a town grew. It became a city called Mostar—which is simply *stari* and *most* reversed and elided. Islamic mosques with towering minarets and sumptuous gardens went up. Taxes were collected. People who were willing to call themselves Muslims and their god Allah paid lower taxes and were granted exemptions from military duty for their sons. Mostar thrived and became the capital of the land known as Herzegovina. To the northeast, in Bosnia, Sarajevo prospered in similar fashion.

By the middle of the final decade of the twentieth century, all this history hung over the Neretva from the severed span of the Old Bridge. All this history is what Laura Buxton had come to this spot to paint.

She would commit to canvas this place and this moment, in which a small part of mankind seemed determined to deny its past and, if it survived at all, to build a future out of falsehood. Laura Buxton would paint the vestiges of civilization. She would paint landscapes of ageless, irreplaceable history ruined by the temporary insanity of war. In the war zones of Mostar and Sarajevo, with time off to capture a few landscapes in the Balkan countryside, Buxton would paint, trying to teach her canvas and paper the causes of this insanity.

✑

The Neretva is almost as important in Europe's past as the Nile is in Egypt's. Romans conquered the tribes that lived along the Neretva's banks back in the third century B.C., and the river came to mark the split between the eastern and western halves of the Roman Empire. Five centuries later, Christianity could have drawn much the same line to distinguish the domain of the Roman Catholic Church from the lands and peoples of Eastern Orthodoxy. And by the end of the fifteenth century, the river was the northernmost pride of the Ottoman Empire, marking the extent of the spread of Islam under the rule of Turkish pashas. Stari Most bridged not merely a river, but centuries and civilizations as well.

By the middle of the twentieth century, the one-horse-wide bridge was the most public

monument in all of Bosnia-Herzegovina, the most culturally diverse region of what most of the world knew as Yugoslavia. Lovers held hands and kissed as they crossed Stari Most. Boys dove from its apex for cheers and coins; it became the site of a serious diving competition. Muezzins called the times for prayer from the point of its arch. Swallows swooped around it and launched themselves skyward from its afternoon shadow. Cadets from the nearby military academy proved their courage by flying their planes between its legs. Poets compared it to a rainbow, to a new moon rising from the water. Men were executed on this bridge.

In November 1993, eight months before the artist arrived to paint its picture (figs. 1 and 2), Stari Most was blown away by some of the very people who had crossed the bridge and who well understood its importance. Their guns were not aimed at an invading army, not even at an economic or political rival, but at the past. This act of the late twentieth century's Balkan tragedy was a turning point in the war against history.

⁂

By the time Laura Buxton arrived in the summer of 1994, Bosnia-Herzegovina was under a cease-fire, so there were plenty of people about, even though many of their cities and public places had gone to rubble. There were people standing on the ruined bridge as she studied it from across the river and began to sketch. Yet Buxton included no people in her painting, only the rubble.

In fact, there were confused, displaced, war-weary people everywhere as she applied her paint and ink, but Buxton chose not to distract us with their thousands of personal griefs. Her work insists instead that we focus on war's ruined landscapes. Thus, but for the architecture and the pox of mortars, *Approaching the Check-Point* (fig. 3) could show a ghost town in the American West.

Like most outsiders in Europe, Asia, and America, Buxton had watched the Balkan war on television and failed to make out the why of it. It seemed to her that "there is really so much more beyond the blood and the guts. It was much deeper and multifold. As an artist, I felt this tremendous responsibility to say something that would be worthwhile, that other people could see. And even if they couldn't understand, they could at least gain some insight from a different point of view. I could give them something, perhaps, that hadn't been fixed on before."

So in her work, she fixes our attention on a row of houses, a fence, a sidewalk, lifeless utility poles, and leafless trees. In *A Break in the Frontline* (fig. 4), by locking out individual suffering, she strangely makes us feel a universal loss. More than Balkan history lies dying in the dust around Laura's easel; it is the history of our own civilization. Buxton's oils and ink confront us with time crumbling, collapsing before our eyes. Half a millennium and more of cross-fertilization between Eastern and Western civilizations lies on its deathbed.

Her eye could not resist the occasionally sweet

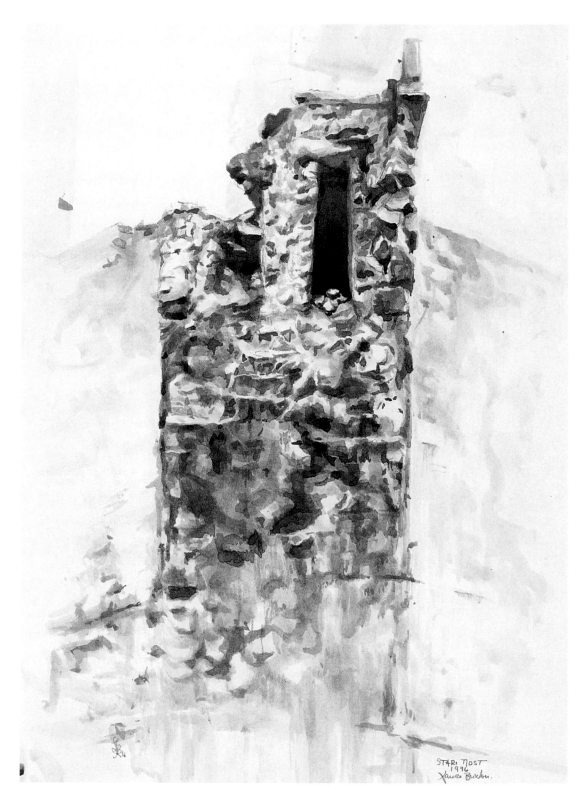

Figure 2
Stari Most
Sepia

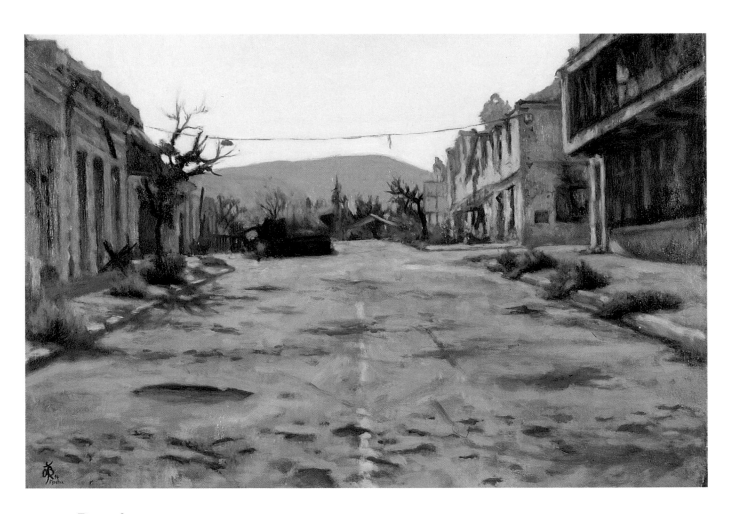

Figure 3
Approaching the Check-Point
Oil

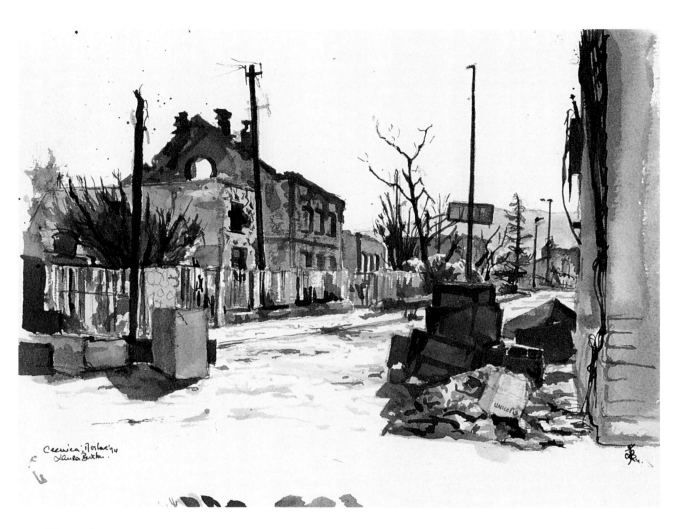

Figure 4
A Break in the Frontline
Sepia

juxtaposition of time and culture, sunlight and shadow, as in *The Well in Use Again* (fig. 5), where a modern tin can has been recruited for bucket duty beside a timeless stone well. But in *Charred Remains of Town Hall* (fig. 6), the stench of human betrayal rises from the canvas and envelops us. Painting inside the burned-out town hall of Mostar, Buxton found herself oddly alone, away from the curiosity and the compliments of survivors. "What was left of the staircase was buried in several feet of ashes," she wrote on the back of her canvas. "The long, silent passages, burnt black, purple and blue, left the senses chilled." Perhaps it was the passing of history's ghost she felt.

Of *Museum of Bosnia-Herzegovina* (fig. 7), she noted, "I sat on the opposite bank by the water to paint this. It was evening and tranquil after the hot days. The chimes of the bells beckoned the Catholic people to evening mass and the Mullahs called out their prayers. They agreeably resounded together down in the valley when all lived without hatred side by side. In the distance the dull thunder of the fighting continued on the front line three miles away." Once, the museum held a prize collection of pre-Ottoman artifacts, which were removed early in the siege of Mostar. Now, roof split and walls blown apart, it seems about to lie down on the riverbank and give itself over to the encroaching jungle of its gardens.

Then there is *Hotel Neretva* (fig. 8). Like the museum, the hotel was constructed around the turn of the twentieth century, when the Balkan states known as Bosnia and Herzegovina were ruled by the Hapsburgs of Austria and Hungary. The hotel was built on Marsala Square, where soldiers of the Turkish army once prayed before going off to battle. The best rooms had river views.

Communism under Marshal Tito brought new history and new architecture, fresher bones for the dogs of war. The subject of *Razvitak Department Store* (fig. 9), once an eight-story emporium, was "well targeted," the artist noted, so that it began "collapsing symmetrically." *Previously a Bookshop* (fig. 10) depicts what is now little more than a shadow box for slag; an iron bar leans in an arch, useless for preventing entry, were there anything to enter for. Buxton also painted a composition of rectangular shapes that could pass for a Tomb of the Unknowns but for the title of her canvas, *The Record Shop* (not shown). If "ethnic cleansing" is to be accepted as the ultimate goal of these Balkan wars, one can only marvel at the buildings targeted for destruction.

Except for *The Well in Use Again*, which was done in Medjugorje, all the works in this section are from the city of Mostar. It was in Mostar that Laura Buxton did the bulk of her work in 1994, until the cease-fire collapsed and she retreated to London, where she organized an exhibit. She returned in 1996, dividing her time between the two fondest targets of the Serbian offensive, Mostar and Sarajevo.

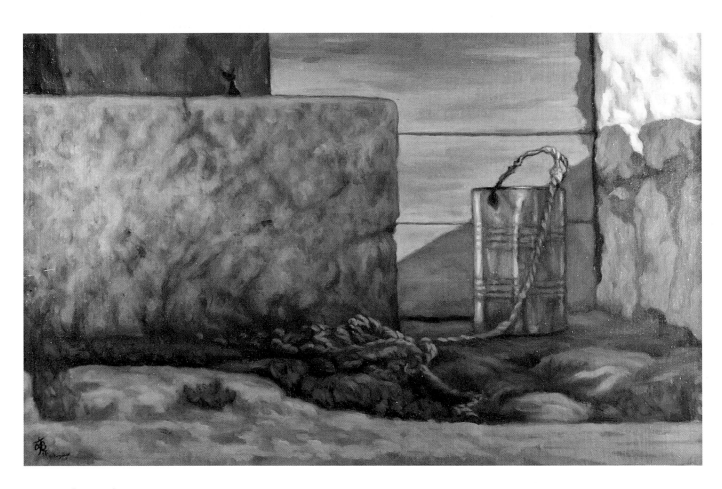

Figure 5
The Well in Use Again
Oil

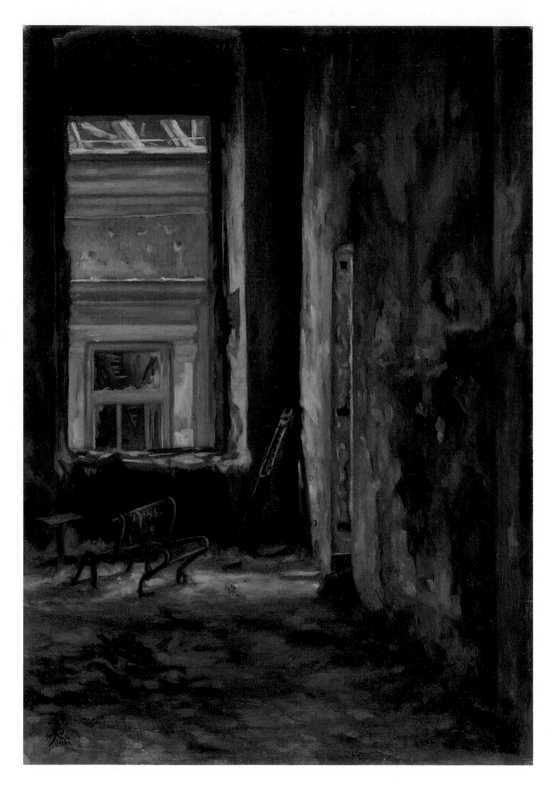

Figure 6
Charred Remains of Town Hall
Oil

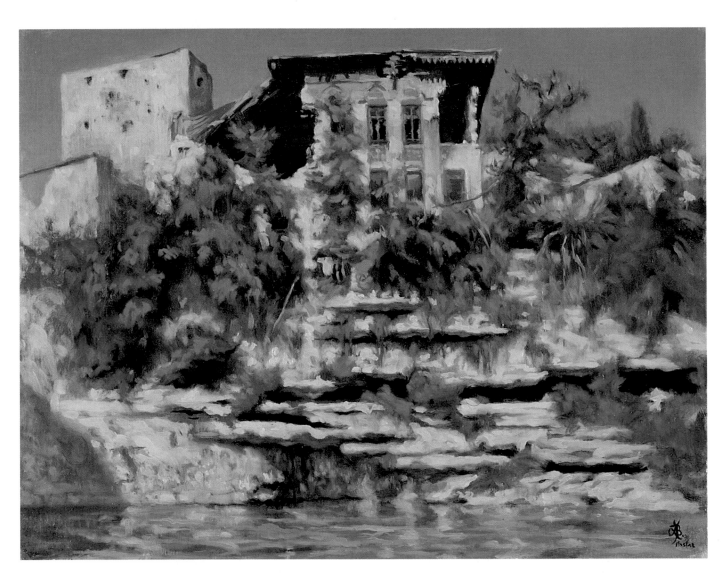

Figure 7
Museum of Bosnia-Herzegovina
Oil

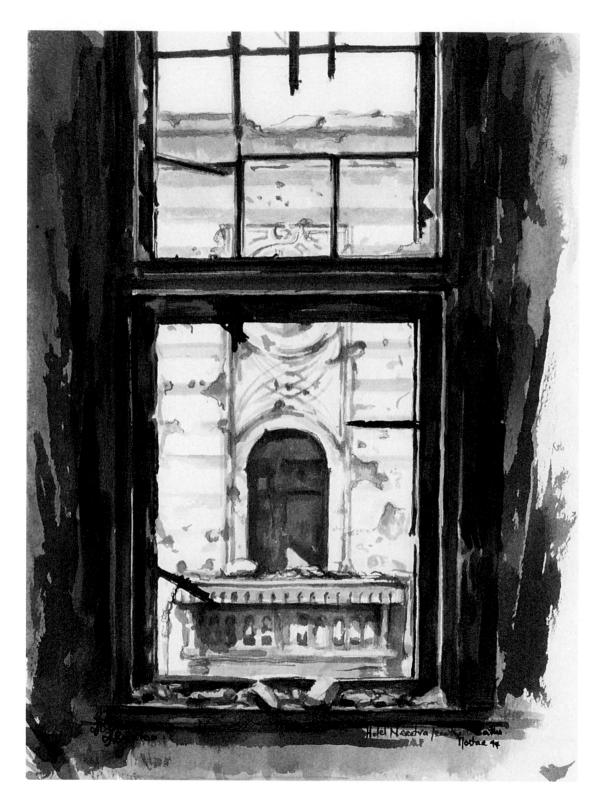

Figure 8
Hotel Neretva

Sepia

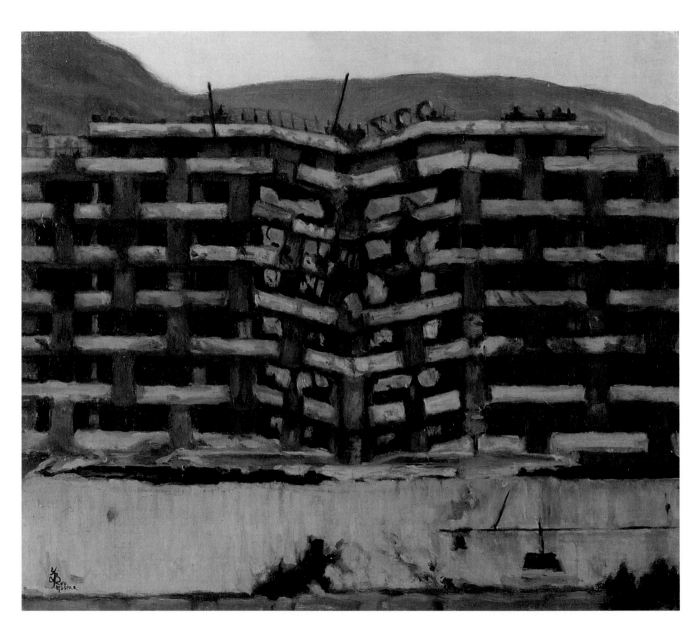

Figure 9
Razvitak Department Store
Oil

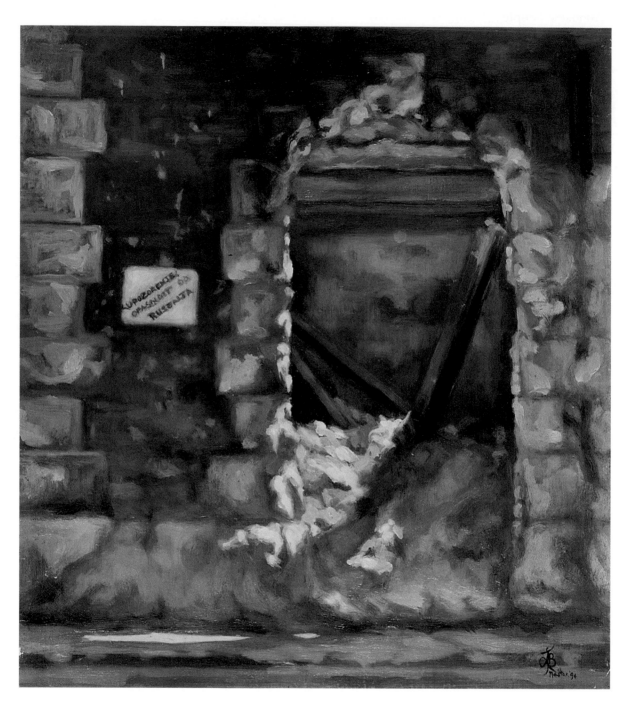

Figure 10
Previously a Bookshop
Oil

The Yugoslav People's Army took over Mostar in 1991, at the beginning of the post-Communist breakup of Tito's federation. Both Serbs and Croats aimed their separate guns at Mostar in 1992. There were truths in Mostar that could not be effectively denied unless they were first eradicated. The images Laura Buxton found there and committed to canvas, such as that of the *banja*, or public Turkish baths (*Bagna I*, fig. 11), seem very much like little truths slipping through civilization's fingers. *Tito Most* (fig. 12) depicts the destruction of a relatively modern automobile bridge across the Neretva, which could have been justified in a territorial dispute. But the Old Bridge, as depicted in *Vestiges of Stari Most* (fig. 13), was never wide enough for a military vehicle. Such destruction forced the people of Bosnia-Herzegovina to look hard at where their leaders were leading them.

Just about the time Buxton began her odyssey of oils and ink, a Croatian journalist whom she much admired, Slavenka Drakulic, told a European commission on the Balkans that she felt "more pain looking at the image of the destroyed bridge than at the image of the massacred people," as though she might be anticipating Buxton's work. Drakulic testified, "We expect people to die; we count on our own lives to end. The destruction of a monument to civilization is something else. The bridge, in all its beauty and grace, was built to outlive us. It was an attempt to grasp eternity. It transcended our individual destiny. The death of a man is one of us; the bridge is all of us forever."

The Balkan region has a tendency, Sir Winston Churchill once remarked, to "produce more history than it can consume." The paintings and drawings of Laura Buxton stand as a warning to the rest of the world that no amount of history is safe from the fires of self-immolation.

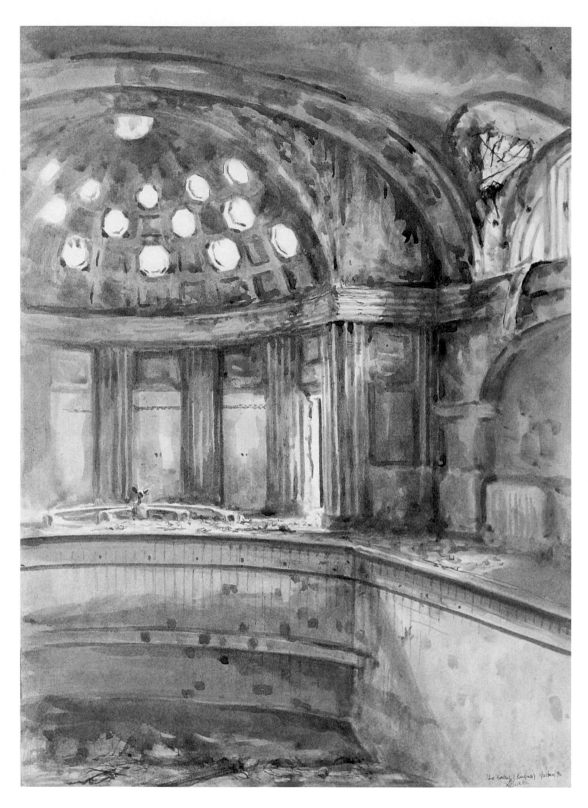

Figure 11

Bagna I

Sepia

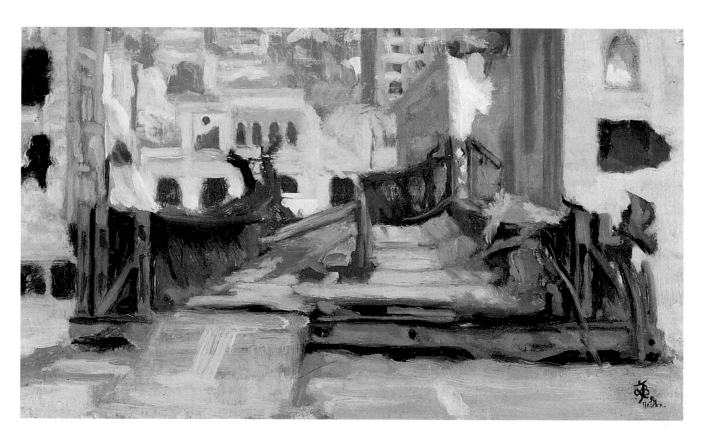

Figure 12
Tito Most
Oil

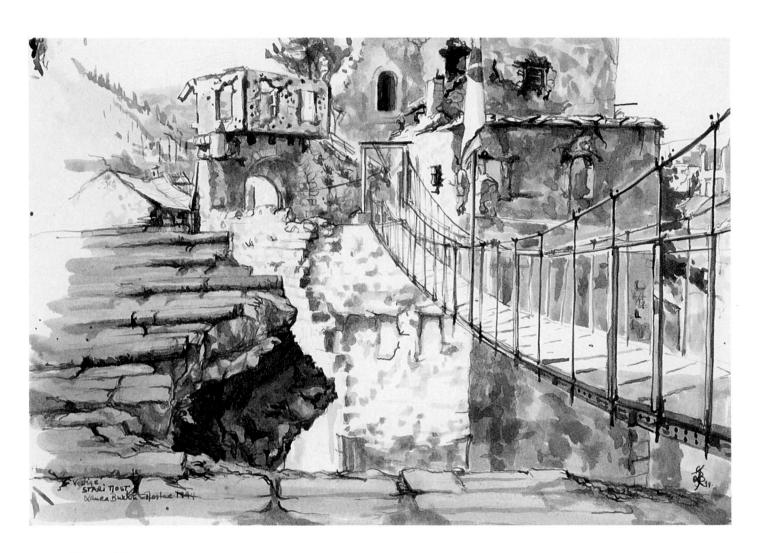

Figure 13
Vestiges of Stari Most
Sepia

Part Two

RATNA ZONA: WAR ZONE

Mostar's population was 130,000 before the war. One-third of those were Muslims or Bosniaks, one-third Croats. About one-fifth called themselves Serbs, and the rest identified themselves simply as Yugoslavs. By the time Laura Buxton arrived in Mostar with her canvases, only 60,000 people remained in the city, roughly split between Muslims and Croats. Since everyone she met looked and sounded very much like everyone else, the artist painted their streets and homes, their places of business, without regard to ethnicity or religion, with little regard for the labels they affixed to one another. She was in the *ratna zona*, the war zone, where fear played no favorites.

Buxton had looked at the map before leaving Paris. She had read the names—Serbia, Croatia, Bosnia-Herzegovina, Slovenia, Montenegro, Kosovo, Macedonia, Voyvodina, areas of bright color within the Balkan region. Until recently, most of those political subdivisions could be called Yugoslavia, which means, literally, "land of the southern (or *yugo*) Slavs." Anyone who spoke a Slavic language, such as Russian, Polish, or Czech, could be considered a Slav.

The people of Kosovo, Croatia, Bosnia, and the other subdivisions were mostly Slavs and spoke Slavic, yet they turned some of their most cherished cities into *ratne zone*. Some of them wanted

to govern themselves, wanted to take control of those areas defined by boundaries drawn on maps. Others wanted to retain central control from Belgrade, the capital of Serbia and of Josip Broz Tito's Communist federation of Yugoslavia.

On the Boulevard: the Front Line (fig. 14) sets us down hard in the *ratna zona* of Mostar, the guns fallen silent for a while and the unseen people trying to put their lives back together.

Some of the people of Mostar identified with Croatia; most of these belonged to the Roman Catholic religion. And there were other people who called themselves Bosniaks; they were descended from families that embraced Islam sometime between the fifteenth and nineteenth centuries and were therefore officially labeled Muslims. Before the war, there were also a fair number of people in Mostar who proclaimed their allegiance to the Serb-dominated Yugoslavian government, and usually to the Orthodox Christian Church as well. And there were also a number of Jews.

Yet all of Mostar's people were Slavs, and each of them now had to face twisted steel beams lying in the rubble of stone buildings, crumbled like so much stale cheese on a plate of deep blue sky. *On the Boulevard: the Front Line* depicts one of their city's main thoroughfares. On building walls chipped by bullets, residents have taken paint in hand to warn one another in large letters, "*Pazi!*" which means "Watch out!" The words below, borrowed from our own language, speak for themselves: "*Snajper non-stop!*"

On the back of her *Boulevard* canvas, Buxton wrote,

> By the end of July they opened up the checkpoint on the boulevard between east and west, Muslim and Croatian Mostar. Between 7:00 A.M. and 7:00 P.M. women and children could cross. They could stay up to three days, although most seemed to do less. With families being separated for two years, this was very welcome, but permission and papers had to be obtained and that wasn't always so easy. I sat by the tent until 7:00 P.M. to paint this painting. All the while I listened to and saw the streams of women and children struggling with luggage filled to its limits with either food or some belongings.

Actually, it had been but one year since May 1993, when the final Croatian mortar and rocket barrage brought Mostar to its knees, earning it the cynical nickname "Beirut of the Balkans." Muslims were ordered to hang white flags from their homes. Muslim men were sent to concentration camps. The women and children were herded with brutal boot kicks and gunshots fired just above their heads into a little Muslim enclave just on the east side of where Stari Most used to be. This was to be their ghetto. For ten weeks, not even food or medicine was allowed in to them. These were the people who streamed by her easel as Laura Buxton painted.

Automobile carcasses are everywhere in Buxton's Mostar. *The Defeated Defender* and *Frontline Barricade* (figs. 15, 17) show the wreckage of

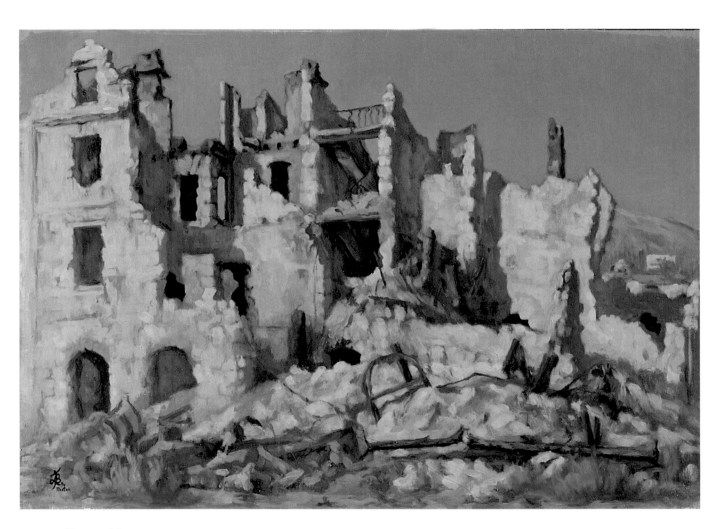

Figure 14
On the Boulevard: the Front Line
Oil

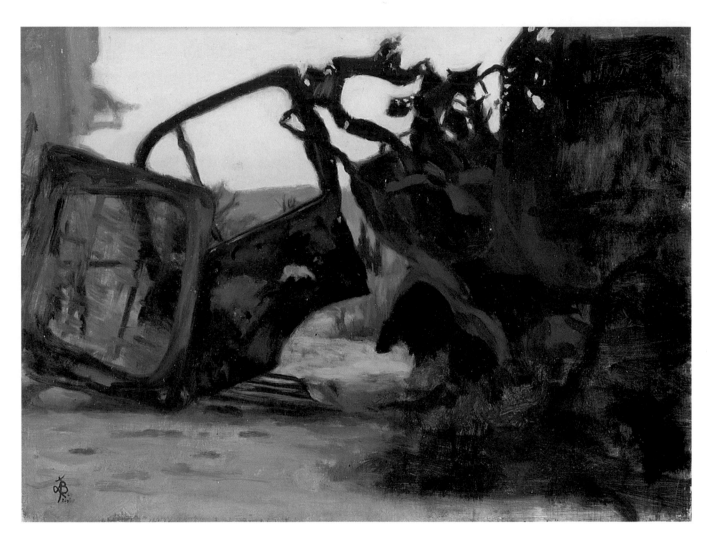

Figure 15
The Defeated Defender
Oil

Figure 16

Inscription on the reverse of *The Defeated Defender*

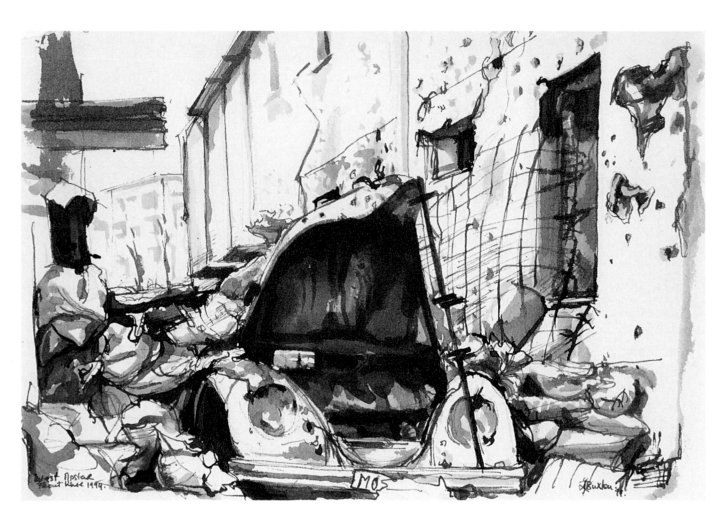

Figure 17
Frontline Barricade
Sepia

cars employed as barricades against the two-year barrage of shells and bullets. *A Dead Yugo* (fig. 18) shows one such carcass lying before the minaret of a mosque, and *Jozo's Mercedes* (fig. 19) depicts a battered black sedan in shadow before a sun-draped garden wall. "During the worst periods of the war," reads Buxton's inscription on this painting, "the opening in the street was named 'Sniper's Alley.' The Mercedes probably brought protection to some during that time, then later became a playground for the children."

Growth in a *ratna zona* isn't easy. The subject of *Tree on the Frontline* (fig. 20) has sacrificed its leaves and much of its bark to the steady cross fire, yet there may be life hidden deep in the roots. There is life in the people, too; a few of them have managed to live out the madness in the cellars of their homes.

It is the homes no longer habitable that tell the most sorrowful stories. Witness the brooding *Dr. Jazin's House After the Inferno* (fig. 21). The house is located on Ulica Marsala Tita, or Marshal Tito Street. Could anyone ever have lived here? "The doctor would come and talk to me sometimes while I was painting and tell me about the home he had and the life he lived within its walls," Buxton notes. "The house burned for three days, and Dr. Jazin lost everything."

The wrecks on Ulica Aleksa Šantic (figs. 22–24) are barely recognizable as houses, but for the gatepost in *Šantic II*. The area is just to the right of that depicted in *Approaching the Check-Point* (fig. 3).

War, Ulica Brace (fig. 25) shows what is "just another ordinary person's modest home."

One of the Muslims living in Mostar's *ratna zona* was local historian Mili Brankovic. He worked in the city's archives, which somehow escaped the war intact in the midst of buildings carved and cratered by shells. Brankovic spoke in 1996 with Radio Free Europe. He took issue with the news media's casual labeling of the wrecking of Bosnia-Herzegovina. It never was a war among Bosnia's Muslims, Croats, and Serbs, he insisted. To say that was to throw dust in the eyes of the world. Before the Turks came, everyone in Bosnia and Herzegovina was Christian. But "bad geographic luck," as the historian put it, placed them at the dividing line between Rome and Constantinople, affixing "Catholic" and "Croat" labels to one group of Slavs, "Orthodox" and "Serb" labels to the other group.

The dividing and labeling got more complex in the early Middle Ages, when Manichaeism swept through the Christian world. Its followers in the southern Slavic region called themselves Bogomils. Winning millions of converts by encouraging communities to name their own priests, Manichaeism held Christians individually responsible for recovering the lost paradise of earth for God's kingdom. Each Bogomil pledged himself personally to fight evil. The Catholics and Orthodox Christians pledged themselves to fight Bogomils.

The doctrine—branded heresy by both Rome and Constantinople—had much in common with

the Islamic faith. Consequently, when the Islamic Ottoman Empire moved into the region from the east in the fourteenth century, the Bogomils were quick to align themselves with the new Turkish government. That not only bought them protection from their Catholic and Orthodox neighbors, it also gave them favored-citizen status and exempted them from the *dzizja*, the tax imposed by the Turks on Christians. Throughout the Ottoman Empire, Muslim converts paid lower taxes and held all the important positions, and the Christians of both churches became second-class citizens.

By the time of Communism's decline in the 1980s, the cities and cultural institutions of Bosnia-Herzegovina were largely in the hands of the descendants of the Bogomils. Only now, they were known as Bosniaks, and just a tiny percentage of them actually practiced the Muslim religion. In fact, most nominal Muslims enjoyed Western music, drank wine and plum brandy, and ate pork. Decades of relative prosperity and Tito-style Communism had blurred whatever distinctions might have incensed the ancestors of modern Bosnia-Herzegovina.

But Communism's collapse created a vacuum that demagogues were only too eager to fill. By convincing individuals that history entitled them to someone else's property, the demagogues quickly mustered armies. The eradication of certain physical structures and the driving out or partitioning of certain types of people allowed the controllers to establish the illusion that history supported their claim to power. By erasing the chalk marks of history, they made a clean slate for writing their new myths. They invented whatever past might support their vision of the future.

But even the best erasers leave smudges, and in Laura Buxton's paintings can be seen the smears chaos has left on time's chalkboard.

In 1995 testimony, the Commission on Security and Cooperation in Europe heard that the ruined landscapes of the Balkans were the result of "tensions created within living memory." Harvard bibliographer Andras Riedlmayer argued that this was "a war of twentieth-century ideologies." The pick-and-choose history of the Serbs and Croats had generated an "exclusive nationalism which denies Bosnia's multicultural past."

Indeed, it was not so long ago—just before the war, in fact—that East Mostar attracted hundreds of thousands of sightseers from around the world. They came to view its mosques, its tiled and arch-windowed Old Town, its historic Turkish houses. They came to stand on its soaring Stari Most and look down on the deep green, roiling Neretva. They came and left in peace—and the signs of their passage were hard to obliterate. As Laura Buxton chose her subjects from Mostar's tortured landscape, she saw twisted guideposts ripped by shrapnel, holed by bullets, and rusting at the edges. In five languages, stubborn markers touted at the ghosts of tourists: "A Bit of the Orient in the West."

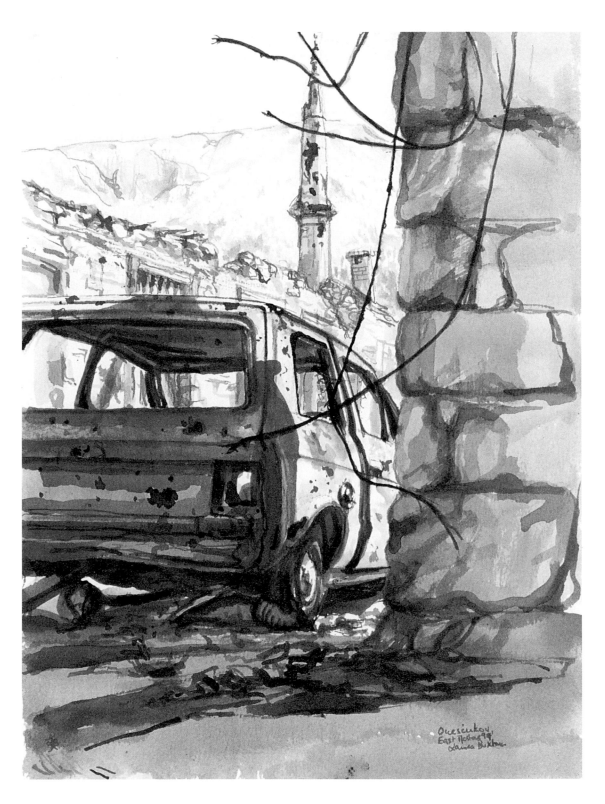

Figure 18
A Dead Yugo
Sepia

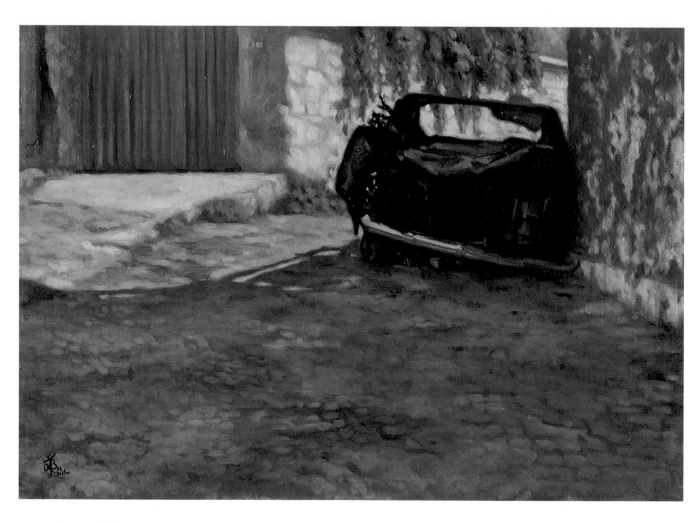

Figure 19
Jozo's Mercedes
Oil

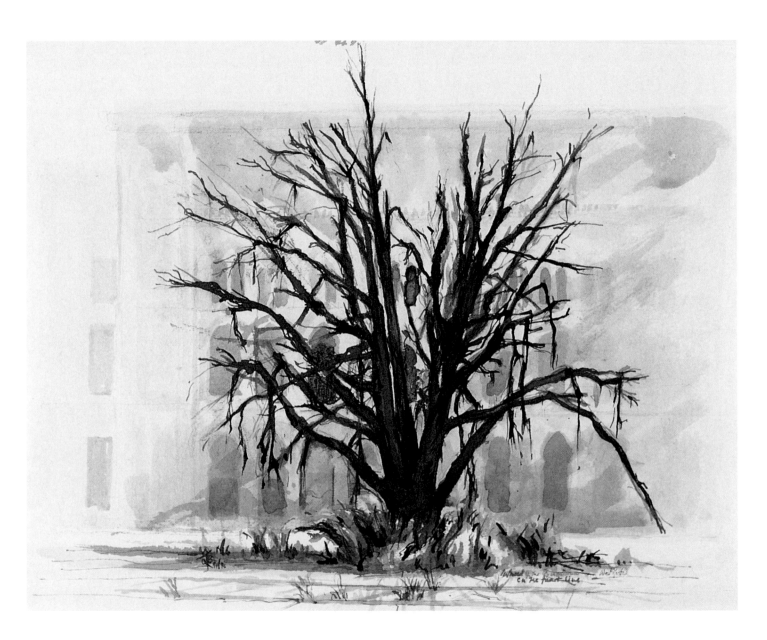

Figure 20
Tree on the Frontline
Sepia

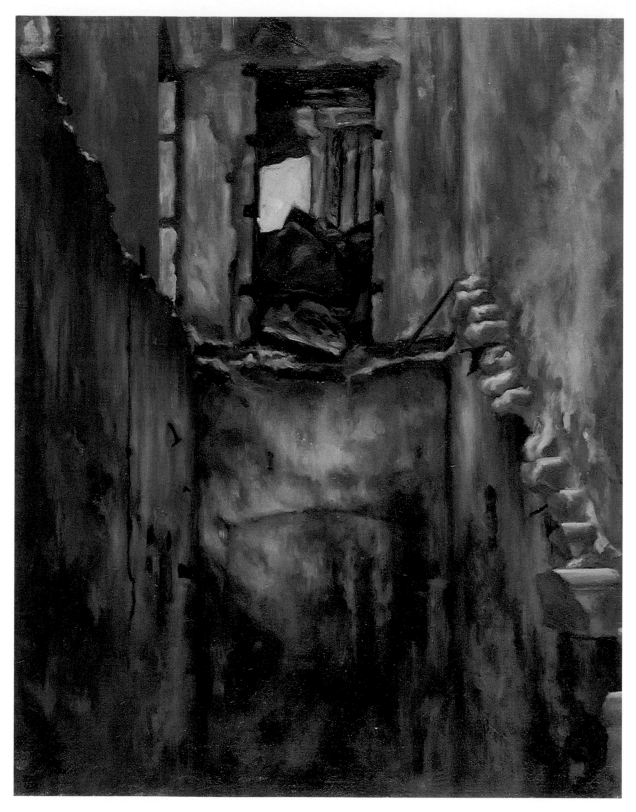

Figure 21
Dr. Jazin's House After the Inferno
Oil

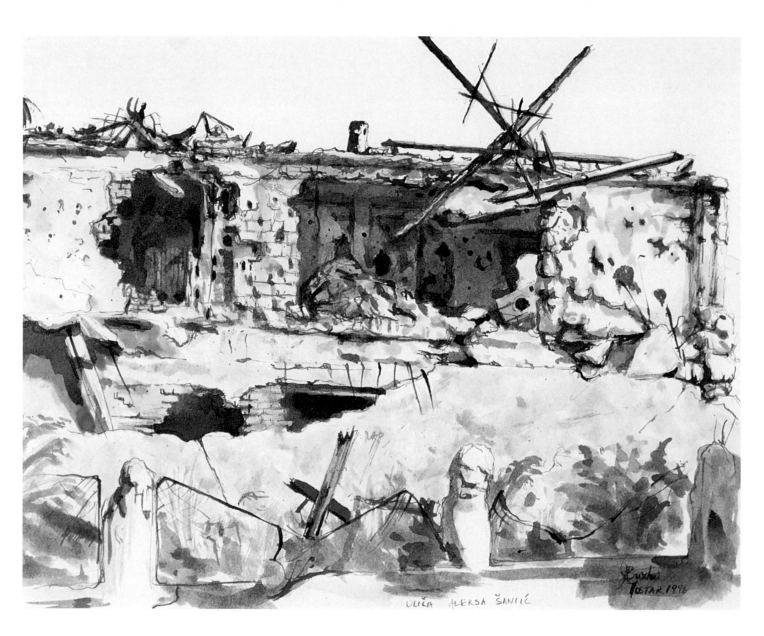

Figure 22

Ulica Aleksa Šantic I

Sepia

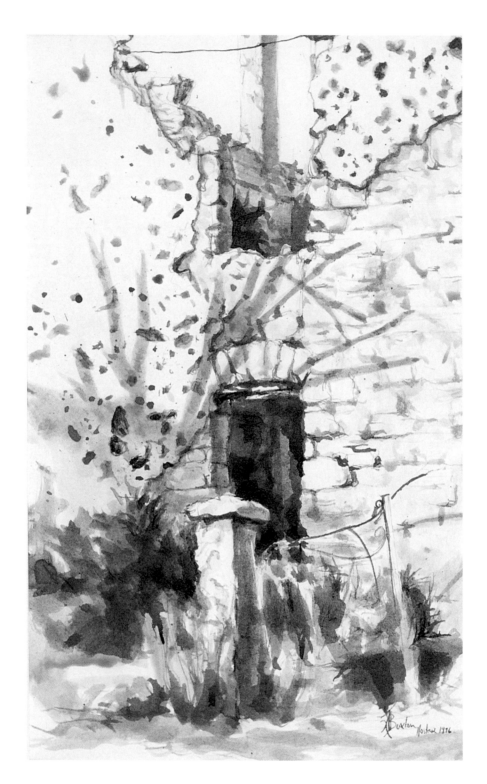

Figure 23

Šantic II

Sepia

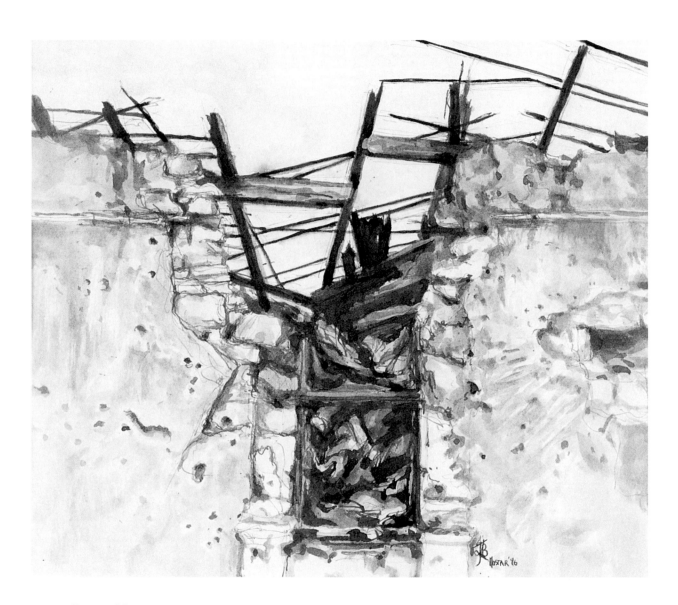

Figure 24

Šantic III

Sepia

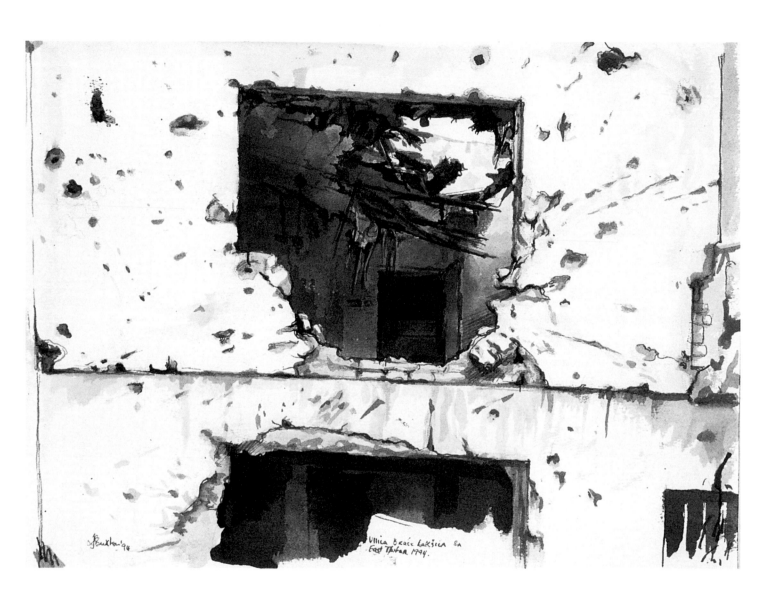

Figure 25

War, Ulica Brace

Sepia

Part Three
U N A N S W E R E D P R A Y E R S

"Sanctuary!" shouts Quasimodo on the steps of the great cathedral, certain of safety in a house of prayer.

There was no sanctuary in the Balkans. Cannon shells ripped through domed mosque roofs even at Friday noon, when the few believers among the local Muslims were gathered to hear the weekly *khuthahi* and follow the imam in prayer. Mortars rained terror on Catholic and Orthodox icons alike. Nothing could cripple the manifold culture of the Balkans at a more fundamental level than this deliberate desecration of its religious institutions.

As recently as the 1980s, postcards from Sarajevo and Mostar showed skylines studded with Islamic minarets, Catholic campaniles, and Ortho-dox cathedrals, rising together like fingers of the same hands joined in prayer. Not any longer. Laura Buxton painted the houses of prayer as ground zero. Her domes rise above the rubble like blue eggshells cracked and holed. The promise of eternal life escapes from open wounds. Minarets, weakened by explosions, implore heaven to spare them from toppling in the next strong wind. Cathedrals lie crushed, mortared, martyred.

The first two paintings in this section (figs. 26 and 27) depict an East Mostar mosque named in honor of an important Bosnian during the early period of Ottoman dominance. His name was Hadzi Mehmed-Bey Karadoz, and the mosque is known variously as Mehmed-Bey, Karadoz-Bey, and

Karodjozbega Mosque. It was completed in 1558, when Suleiman's Ottoman Empire spread from Baghdad to Budapest.

In *Bosnia and Herzegovina*, a 1980 book by Alojz Benac and Ivan Lovrenović, "Karodjozbeg's Mosque" is cited as an outstanding example of the single cupola mosque, "in which a perfect harmony was developed: the external appearance proceeding directly from the internal shape." The writers cite Karadoz-Bey's *sadrvan*—a polygonal or circular fountain covered by a roof supported on columns—as one of the finest such "architectural and sculptural miniatures, from which emanates an atmosphere of peace and intimacy." Karadoz-Bey was considered among the most beautiful mosques anywhere, with its sun-dappled, high-ceilinged sanctuary, its elaborately patterned tile floors, its ancient Koran.

During the summer of 1992, Karadoz-Bey endured three months of bombardment from Serbian guns placed in the hills above Mostar. The following autumn, the Croatian nationalist militia turned its cannon on the mosque. Astonishingly, most of the cupola and the entire minaret were still standing when Buxton arrived. Of *Bez Munare* (fig. 26), Buxton wrote,

> During the evening while I was painting this piece, I would stand near one of the main street water pumps where people would come to get water for the night. As they went to fill their buckets, most of them would stop to see the development of the painting. One evening an argument broke out among the people watching me paint, so I asked for a translation. Some of the more religiously sensitive people thought that the minaret should be visible, but most thought it more apt to have left it out, showing just its shadow. The title *Bez Munare* means "without minaret."

Another painting, *Karadoz-Bey Mosque* (not shown), presents the almost undamaged minaret juxtaposed against a less fortunate tottering telegraph pole. *Gallery of Mehmed-Bey Karadoz Mosque* (fig. 27) gives a view from within, past tattered shutters and through an arched window.

In Medjugorje, Buxton met an Irishman who had been fighting for the Croats in Mostar. "He was interested to know how many minarets were left," Buxton said. "I told him there were three standing. He was surprised. Because, he said, their orders had been to shoot every one of them down. The viciousness with which the Croats destroyed every single thing that had to do with the Ottoman Empire was quite frightening. And of course, it is their history just as much as the Muslims' history."

Both the history and the viciousness are apparent in her painting of Mostar's Hadzi-Kurto Mosque, also known as Tabačića. At the close of the sixteenth century, around the time the final stones were being set into the dome of St. Peter's in Rome, construction on Tabačića began in Mostar. The mosque fell in the Bosnian war's first round, on May 6, 1992. In pentimento fashion, Buxton's portrait "remembers" for us the traces of delicate

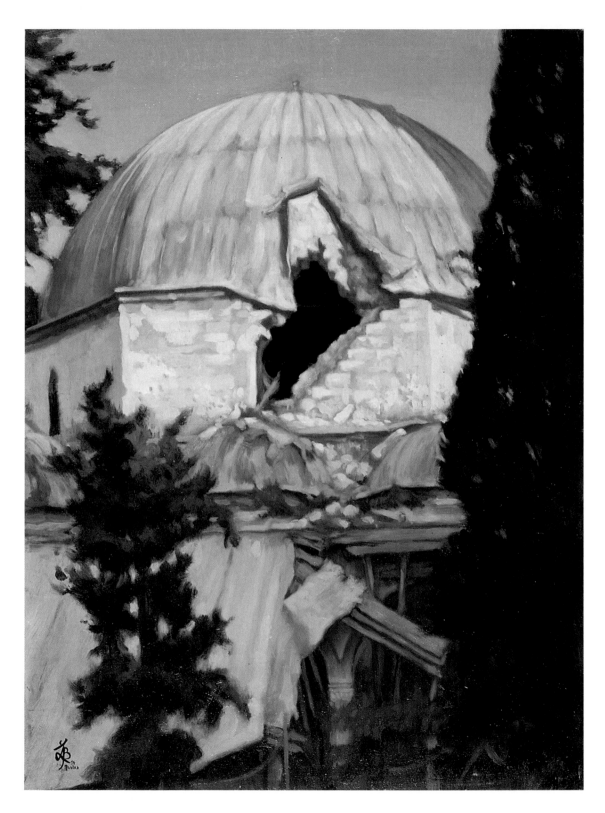

Figure 26
Bez Munare
Oil

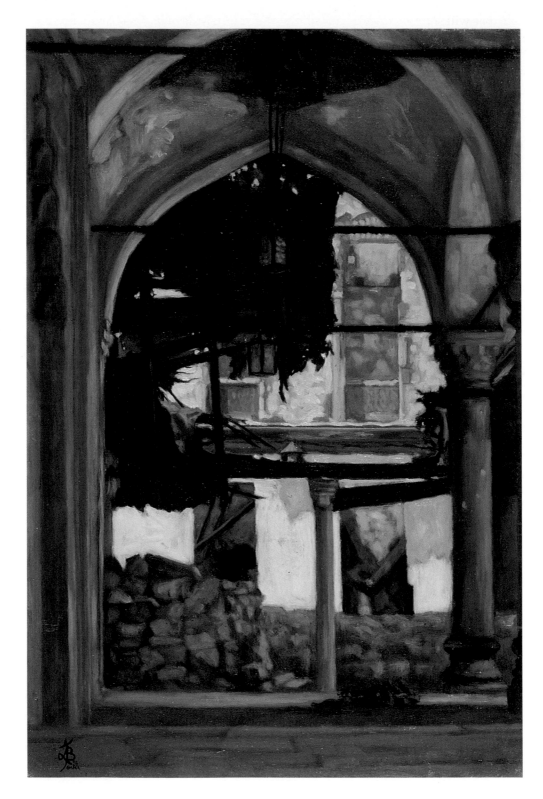

Figure 27
Gallery of Mehmed-Bey Karadoz Mosque
Oil

designs on walls that will soon fall, as the mosque's roof has collapsed in a heap of beam-bones.

On the reverse of *Tabačića Mosque* (fig. 28), Buxton wrote her doubts that the mosque could be restored: "The roofs of the epoch were made of thickly sliced stone, cut in the shape of a fan and layered one over the other. Highly decorative paint work, again in local colours, and inscriptions in Arabic are washed out but visible. Its minaret was one of only three that survived the bombardments, only to collapse in a storm earlier this year."

In all of Buxton's work, no collapse is more complete, no image more visually disturbing than the sepia drawings of the Roman Catholic Church of St. Peter and St. Paul. Buxton leads us like communants up the central aisle of a roofless nave flanked by pews of rubble, through the arch of the narthex, to an altar consisting only of a stark cross of burnt timbers (figs. 29 and 30). Other blackened boards form three letters, not some tradition-heavy message of Christianity, but simply *Mir*, the Slavic word for "peace," perhaps the only prayer left to the people of Mostar. "The priest kept flowers around the cross and altar," reads the hastily scrawled inscription on the reverse side of *Mir—Church of St. Peter and St. Paul*, "and often held masses there for the few who remained in this 'zona rat' close to the front line."

Built in 1850 with the blessing of the Turkish administration, St. Peter and St. Paul Church and its neighboring Franciscan friary were targeted by the Yugoslav National Army in 1992 and burned to the ground. The church's library of ancient religious manuscripts was lost. In 1994, according to the artist, "the church remained barricaded off as the war zone and was heavily patrolled. A labyrinthine system of tunnels and bunkers ran around and through the half-existing structure, serving as protection from the snipers on the frontline. It was impossible to imagine what had been here before." Impossible but for the priest's daily trip to the altar with fresh flowers, but for parishioners picking their way through the ashes to genuflect and cross themselves, but for the single stained-glass window unshattered and unmelted—a depiction of the Virgin Mary.

A few months after the Serbs destroyed the Catholic church, the Croatian National Militia, or HVO, blew up the Serbs' Nova Pravoslavna Crkva, or New Orthodox Church. *New* is relative. The church was built in 1873, in the last years of Ottoman rule. *All That Remains of Orthodox Church* (fig. 31) shows what once was the largest Orthodox church in all the Balkans, collapsed at its center, a Bactrian camel kneeling before a blue sky and lush green mountains.

"Mostar is surrounded by hills on every side," recalls Laura Buxton. "The Serbian Orthodox church was on the east side, high up above the town on a hill. It was actually a monastery, well known for its frescoes. There was a small original church beside it that was several hundred years old. The

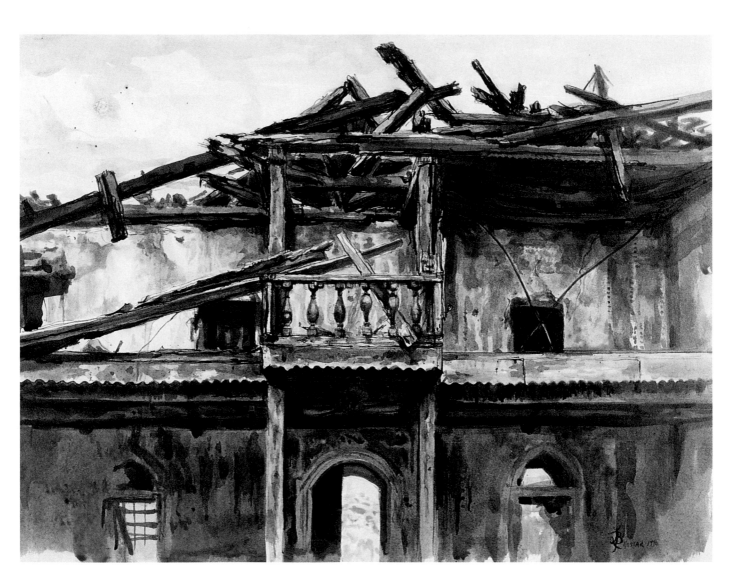

Figure 28
Tabacica Mosque
Sepia

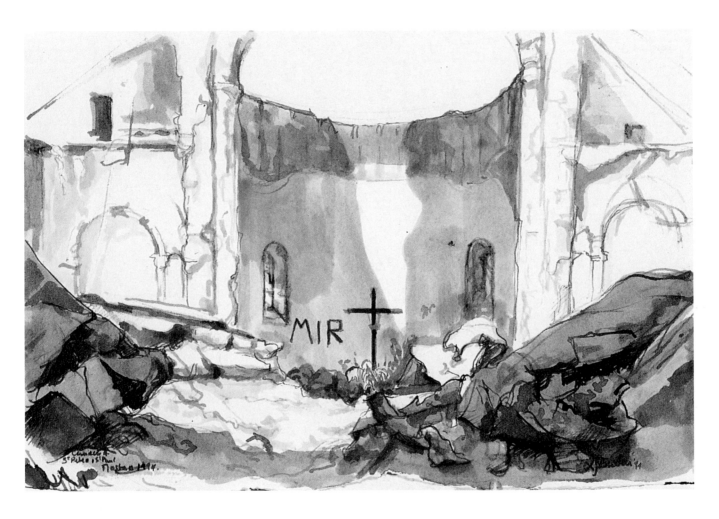

Figure 29

Mir–Church of St. Peter and St. Paul

Sepia

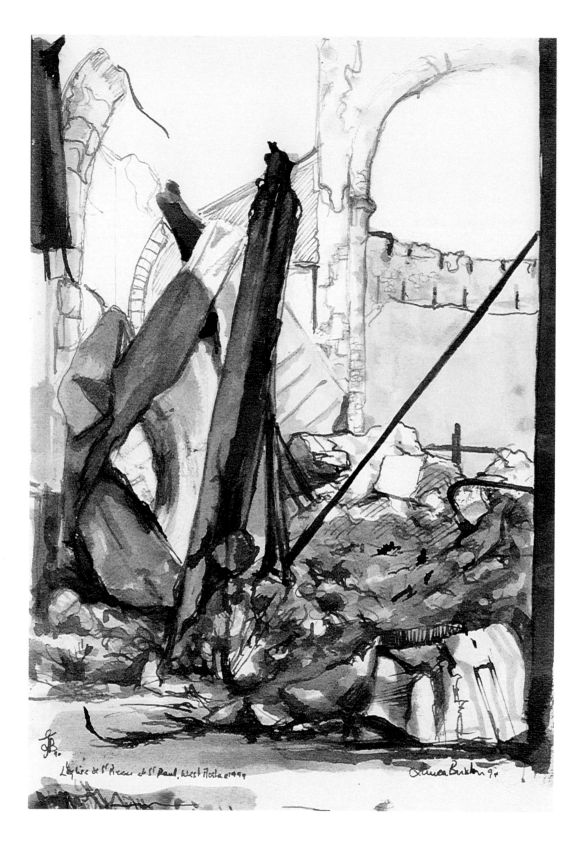

Figure 30
Mir—Another View
Sepia

Figure 31
All That Remains of Orthodox Church
Oil

Serb community tended to live in a quarter just below the monastery, and it was from this particular range of hills that the Serbian army first attacked in 1991. The siege lasted about ten days before the Croats and Muslims pushed them back. However, they remained in these hills until the end."

South of Mostar, in the countryside, Buxton found religious inspiration of a different sort. *Križevac* (fig. 32) depicts a hill above the vineyards of Medjugorje, near the path millions of pilgrims take to pay homage to the Virgin Mary. The hill Križevac (*križ* is "cross") is named for the large cross of St. James Church at its summit. The unexplained spinning of this cross has become, like the vision of Mary, one of Medjugorje's purported apparitions. Although the war dramatically reduced the number of visitors, and even though the republic's Roman Catholic bishops declared in 1992 a lack of evidence of any miracle, pilgrims continued to pass as Laura Buxton painted.

On her way to Bosnia's long-besieged capital, Buxton stopped to draw *Sarajevo, A Muslim Cemetery* (fig. 33), with its line of vertical grave markers and its stone stumps adorned only with carved turbans. Since neither time nor hands were available for carving stone, something new had been added: wooden grave markers for the war-slaughtered thousands.

In Sarajevo, she sat with her drawing pad not in a house of prayer but in a house of learning. All the same, the work she produced there provides an almost religious experience. These are the three sepias titled *Sarajevo National Library* (figs. 34–36), and their story is compelling.

Sarajevo stands on the site of ancient settlements dating from Neolithic times, yet the city emerged as an important commercial and cultural center in the Balkans only after the Turkish take-over. As the Ottoman Empire arrived in the fifteenth century, so did a wave of Sephardic Jews expelled from Spain by Ferdinand and Isabella. The Jews' most cherished possession—which became one of Sarajevo's greatest artistic treasures—was the fourteenth-century "Sarajevo Haggadah," illuminated by medieval craftsmen in Spain. The Haggadah—containing the story of the Exodus, the ritual of Passover, and the narrative portions of Talmudic literature—had survived World War II buried under an apple tree and had come to rest in the Vijećnica, the national library of Bosnia-Herzegovina. In August 1992, the Haggadah was carried out of the burning Vijećnica by a Muslim librarian, who risked his life to save it.

When Buxton arrived, she found arches stippled and scorched, columns sucked of their substance like termite mounds after a sudden flood. If there is any beauty to be drawn from devastation, she has drawn it here (see fig. 48). Her limning of the library's melted carcass evokes a proud rejection of all the generals' lies.

Before the fire, this national library held 1.5 million volumes. Here were deposited a country's

Figure 32
Križevac
Oil

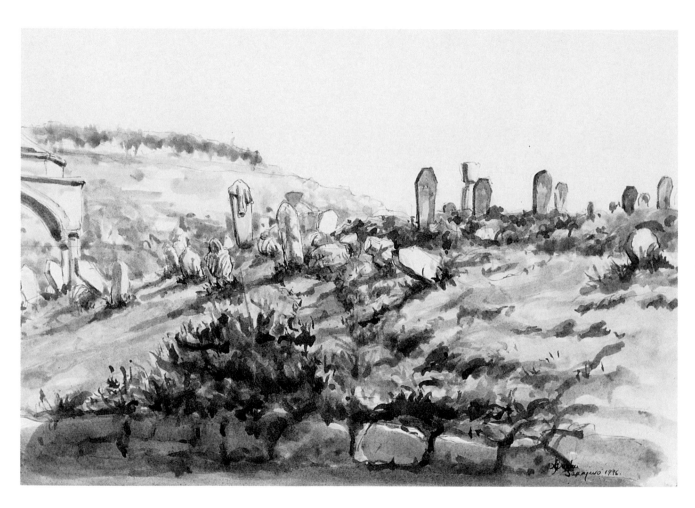

Figure 33
Sarajevo, a Muslim Cemetery
Sepia

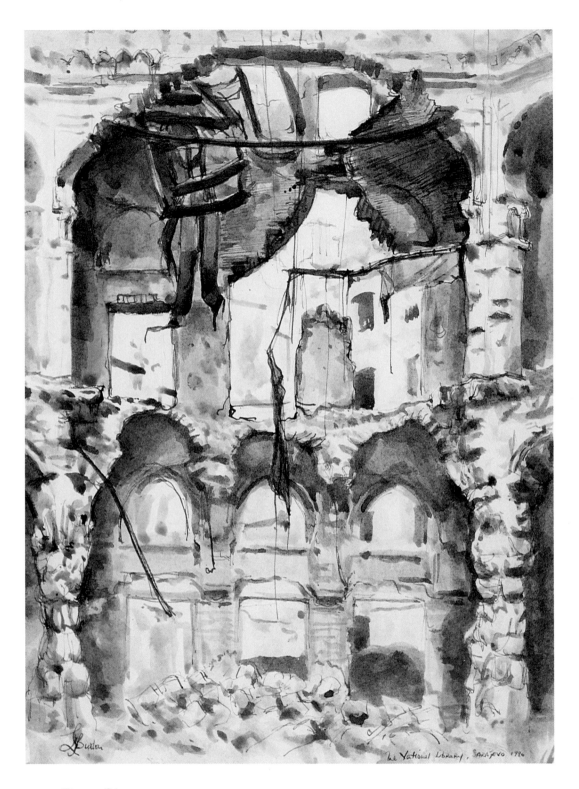

Figure 34
Sarajevo National Library I
Sepia

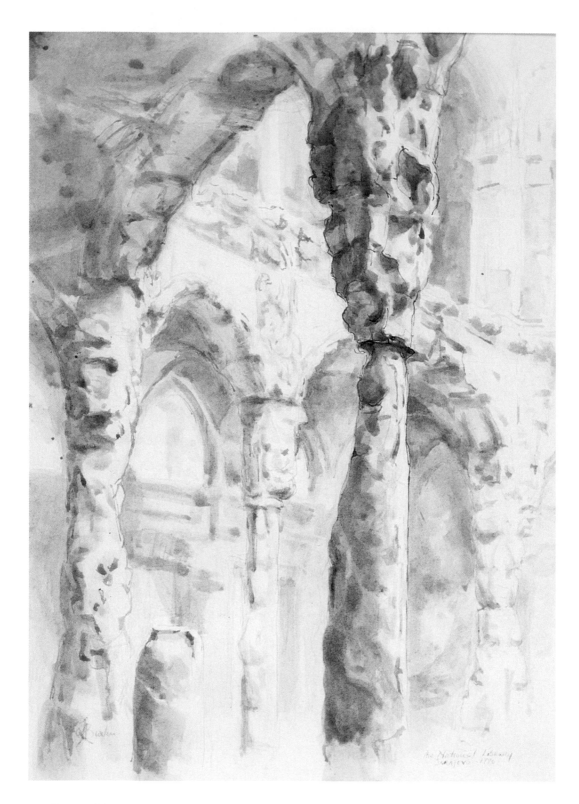

Figure 35
Sarajevo National Library II
Sepia

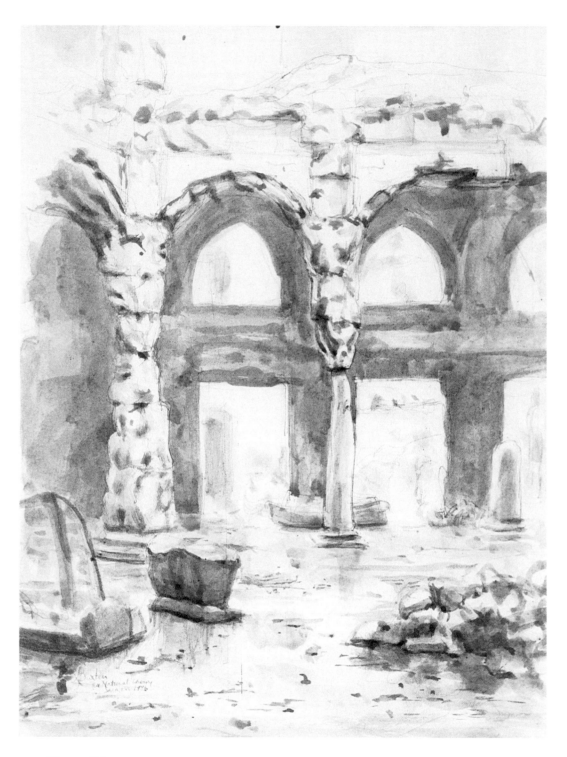

Figure 36
Sarajevo National Library III
Sepia

national archives: 155,000 rare books and manuscripts, 150 years of Bosnian newspapers and periodicals, all the collections of the University of Sarajevo. Eighty percent of this irreplaceable collection went up in flames, while snipers fired at the human chain of citizens who passed along as many treasures as they could move. Interviewed by an American television reporter, one of those citizens said, "We managed to save just a few very precious books. Everything else burned down. And a lot of our heritage, our national heritage, lies down there in the ashes." Another reporter asked a Serb general why shells were falling on a nearby hotel, where members of the media were housed. The officer politely apologized for the inconvenience. The stray rounds had been meant for the library, of course.

For a full week after the summer fire, carbonized leaves of books and manuscripts floated on the wind and fell from the sky like premature autumn leaves, dust-dry, wisdom gone to smoke. Seasons passed before Buxton arrived to find those leaves decomposed into a sodden mulch.

Only the shell of the Vijećnica remained for her to paint. Considering its remnants of groined portals and arched windows, we might be inside a mosque, a temple, or a basilica. In fact, the building was originally a city hall; there was nothing religious about it. Yet there is something in the tyrant soul that thrills to the stench of burning books. What surer proof could there be of history's eradication? This, as the Council of Europe reported laconically in 1994, was "a major cultural catastrophe."

In monochrome portraits of monochrome ruins, Laura Buxton swings for us the censer that ever perfumes the religious ecstasy of war.

Part Four

A SENSE OF WALLS

*B*uxton *chose a curiou*s title for *Stari Grad—the Old Town* (fig. 37). True, her view through two windows of a plastered, peeling wall encompasses East Mostar's old Turkish quarter and the hills beyond. Look through the right window and you'll catch a glimpse of the once-grand Koski Mehmed Pasha mosque, finished in 1618, when the Taj Mahal was nothing but a romantic notion. The Koski Mehmed Pasha mosque fell to the big guns firing from those hills the night of April 23, 1992. Its minaret is that stump behind a tree; its portico is smashed beyond recognition; its dome nurses open wounds. Yet you know at once that this painting is

not of the old mosque or the Old Town you glimpse out the left window. It is a painting, rather, of an old wall.

"Something there is that doesn't love a wall," wrote Robert Frost in "Mending Wall." But in Laura Buxton, there is something that *does* love walls—walls like this one, which once framed a room of small tables in quiet corners and fashioned a space for late arguments and for eating *ćevapćić* and singing a *sevdalinke*.

"This is not the inside of a building left to ruin by disuse," reads her flowing script on the painting's reverse side. "It was a well-frequented café before

the war, situated by the Stari Most until the war began in 1992. Twenty-five metres below these windows flows the river Neretva."

Before the war, it was the cafés Bosnians looked to for true sanctuary. They met their friends there, irrespective of what *narod*—or nationalistic heritage—might encumber them. Mara or Marija, Milos or Mirzad—names might suggest their backgrounds but never got in the way of conversation. They sang songs there. They sang,

> Gdye si mala učičkala skute,
> U šljiviku čekajući diku?
> Tamburice, javorovo drvce,
> Za tobom će puci moje srce.

> Did you preen and primp, my dear,
> Waiting 'neath the plum tree for your wooer?
> Your heart's a mandolin of maple wood,
> And my heartstrings break because of you.

On the café wall, we can read the scuffs of their chair backs and the shadows burned by dark discussion. Out this wall's windows gazed tourists and students, musicians and lovers, intellectuals, artists, deal cutters. Topping off their glasses of sljivovic—the Balkans' dry, colorless plum brandy—or pouring mill-ground coffee from long-handled copper *fildjans*, they could not have imagined that their small café would become a strategic target in the war against history.

Buxton's walls enclose us in a dialogue with time, shutting out the illusion of our own permanence—or theirs. She seems to ask much of walls,

as though she understands the captivating essence of them. Buxton says this has nothing to do with her work as assistant to fresco artist Ben Long, yet it may be that in the process of sealing art into the plaster of buildings, she has unconsciously developed what *New York Times* art editor John Canaday once ascribed to the great fresco painters: a "sense of the wall." At any rate, Buxton's Balkan work suggests that she may know these walls more intimately than she knows what waits beyond them. Even though she applies her paint and ink to canvas and paper, and even though there may be some extra-mural detail with which she wishes to impress us, it is the walls themselves that have become her subjects.

Buxton's walls of stone and plaster are tactile, their colors those of dried blood and bleaching skulls. Craters and cracks made by mortars, heavy guns, and tanks grow like mildew on their surfaces. These walls were constructed not to keep anything out but to define the purpose and delineate the space of those within. And now, they enclose little or nothing. Empty of people and of purpose, they make no sense.

In *Kujundžiluk Quartier* (fig. 38), Buxton takes us into the Old Town of East Mostar, the place we saw from her café window, with its squat, shell-pocked buildings and their stingy windows, slates lifted as by a cyclone and barely clinging to the ridge of roof beams, insulted but unbowed minaret rising behind. The old quarter was laid out by Ottoman architects of the eighteenth century but constructed by local building craftsmen, called

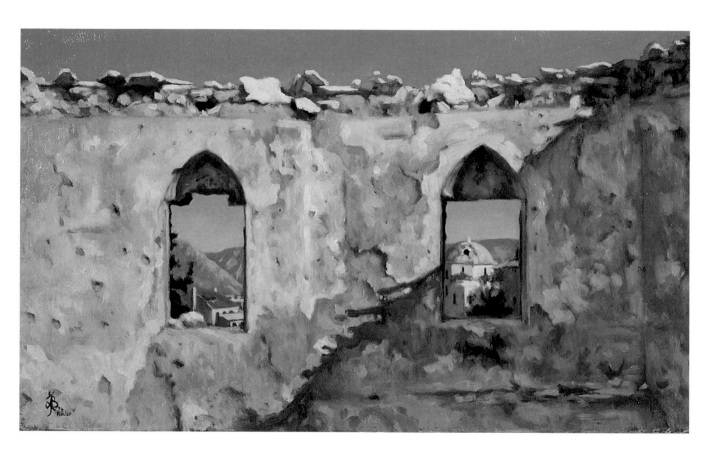

Figure 37
Stari Grad—the Old Town
Oil

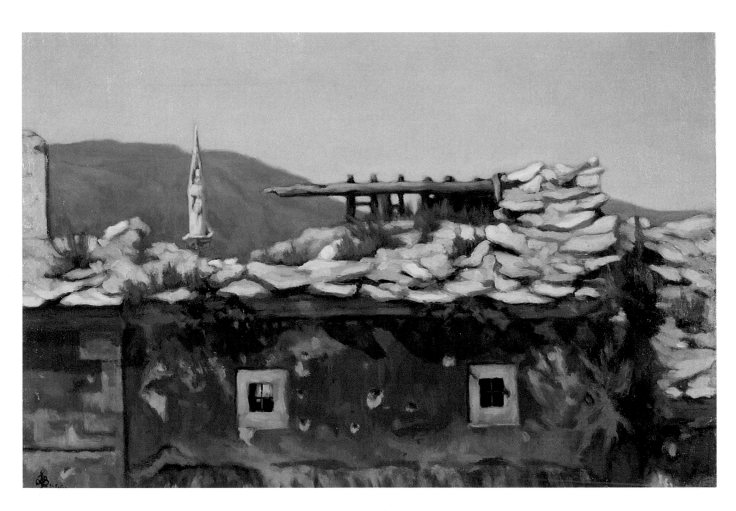

Figure 38
Kujundžiluk Quarter
Oil

dunjas. Here are walls, erected around the time America's independence was being dreamed, with a history all their own. Here are walls shared by cafés, galleries, and antique shops, by leather workers and coppersmiths.

Kujundžiluk fell into disrepair after World War II. In 1950s Europe, as in postwar America, age was out of fashion. In 1976, Dr. Amir Pašić, then director of Bosnia-Herzegovina's Institute of Urban Planning and Preservation of Cultural Heritage, returned to his native Mostar to head up a restoration project in the Old Town. Pasic enticed residents to move from the new city to the old quarter and to relocate their work there. By 1990, space that once went begging at five dollars per square meter was renting at a hundred dollars per square meter, and was hard to come by at that. More than two hundred structures had regained the beauty and mystique of their distant youth. The bazaar was generating millions for reinvestment in the restoration fund, so that the work began to spread to other Mostar neighborhoods. Tourists came by the busload, half a million a year. Then the war started, and history was targeted. The walls of old Mostar, like its minarets and bridges, came tumbling down. Dr. Pasic was understandably bitter. "City haters and city destroyers hound our lives," he said.

As Buxton painted his ruined restorations, Pasic traveled to Washington to tell the Carnegie Endowment for International Peace that "the last twenty-four months in Bosnia have been a time of killing, ethnic cleansing, and destruction, of geno-cide against conventional people." The mayhem, he said, was "driven by psychopathic creators of Big Rage. And we have, as a result, more than half a million wounded, more than one million refugees."

In East Mostar, when residents were under siege, the wounded were taken not to the modern hospital across the Neretva but to the Bolnica Rat, the understaffed, ill-equipped "war hospital" in the old section. Figures 39 and 40 show the red-scarred building to be as wounded as the patients within. Sandbags and boards clot like scabs over windows meant to admit the healing light. The stone wall is broken, like punctured skin, useless for holding back the germs of warfare.

But what walls ever have been strong enough to withstand the madness of war? Jericho's? Troy's? Even the stretch of squat mountains—historically a strategic defense for Romans and Turks and Hungarians—has betrayed modern Mostar, for there's no choicer gun placement than a well-positioned mountain. In *View of the Hume from Pasha's Balcony* (fig. 41) and her accompanying note, Buxton makes the point dramatically. The balcony on which she sat to paint belonged to the family of a young engineer nicknamed Pasha, who, with his wife and twin daughters, lived through the fighting in the cellar of their home at the center of the war zone. During the cease-fire, a group of international aid workers rented living quarters on the top floor, and it was they who brought Buxton up for a look at the impressive panorama. The Hume (or Hum, which is Slavic for an outcropping of rock) "hangs ominously over Mostar," she wrote. "Its beauty

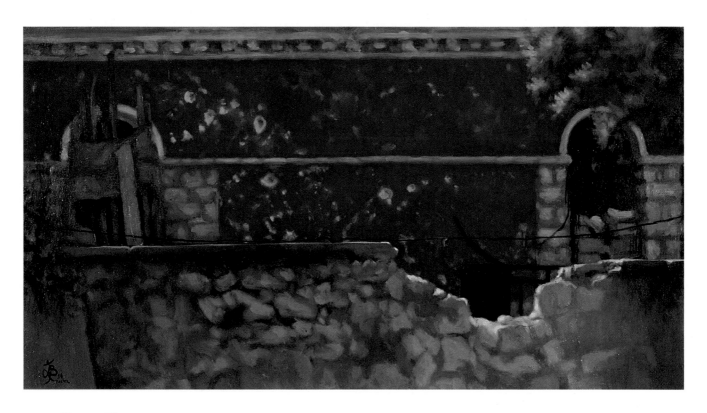

Figure 39
Bolnica Rat
Oil

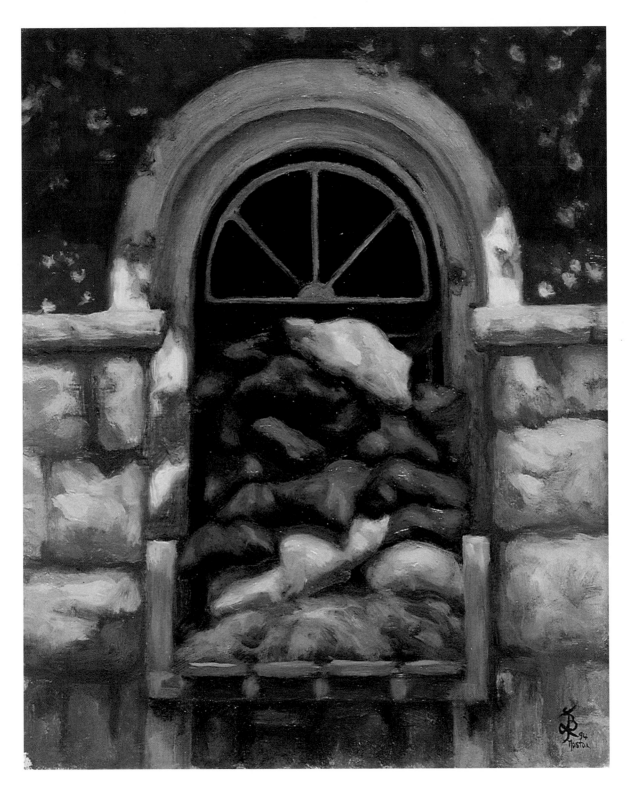

Figure 40
War Hospital Window
Oil

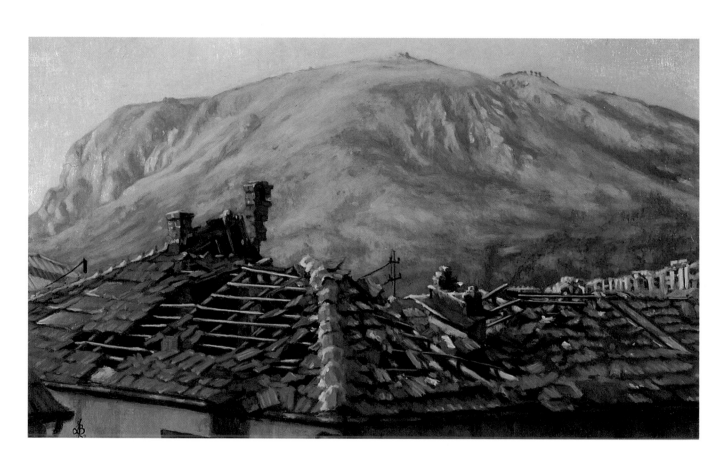

Figure 41
View of the Hume from Pasha's Balcony
Oil

came to represent threat," because it was from the Hum that guns were fired.

In the countryside near Medjugorje, the artist found walls less ominous. *Farm Wall, Medjugorje* (fig. 42) shows a wall with no damage but much character. Pegged to hang belts and hoses for a farmer's tractor, it seems a wall used well on both its sides. *The Ladder* (fig. 43), one of the most eloquent and seductive of Buxton's sepias, suggests the short distance between daylight and darkness, civilization and anarchy. The wall separating the two, narrow and easily scaled, serves the purposes of both equally well.

It is no accident that rural Medjugorje and its bucolic countryside evaded the vitriolic plague. The Balkan wars of the final decade of the twentieth century were fought almost exclusively in the cities of the former Yugoslavia. They were wars against cities and all they stood for—not civil wars but, quite literally, uncivil wars. Civilization and cities depend on one another. Their very names are derived from a single Latin word, *civis*, meaning "citizen." In a city, citizens band together in pursuit of dignity, sophistication, learning, and the time for pursuing them—that is to say, in pursuit of civilization.

In the coffee shops of Sarajevo, the Slavs came up with other words, *raja* and *papak*, to characterize the manipulated citizens of Yugoslavia. In Ottoman times, the *raja* were the rural peasants, simple farm folk who were for the most part non-Muslims. During the siege of Sarajevo, the city dwellers began to describe themselves as *raja*—

meaning that they were tolerant of one another and gave scant regard to religion or ancestral baggage, even though a considerable number of them were of Muslim descent. The word *papak* came to be applied to the modern country folk, among whom old hatreds were kindled by those "psychopathic creators of Big Rage." In the cafés of Sarajevo, people said this was a war between *raja* and *papak*.

Back in Mostar, Laura Buxton painted more warrior walls, such as *A Remaining Chimney Pot* (fig. 44), then finally *Red Ribbon* (fig. 45), whose subject trails from some unseen tower window like Rapunzel's hair. This was her final painting on her first visit to Mostar. The guns drove her out, but she knew she would return. Perhaps the ribbon is there as a means of escape, or perhaps as a means of getting back in. Either way, it casts a heavy shadow, civilization hanging by its own thread on this battered old city's wall.

Perhaps Buxton means to suggest that it is the small and slender presence of her unpainted people that will endure, that will outlast even these pummeled walls. Perhaps the ribbon from a young woman's hair or from a child's dress is a strand of civilization sufficient to hang the uncivil *papak*. Perhaps, in the end, it is the people of Bosnia that Laura Buxton forces us to see.

Agesilaus, king of Sparta, was once asked to explain his unwalled, seemingly defenseless city. The king pointed to his citizens and said proudly, "*These* are Sparta's walls."

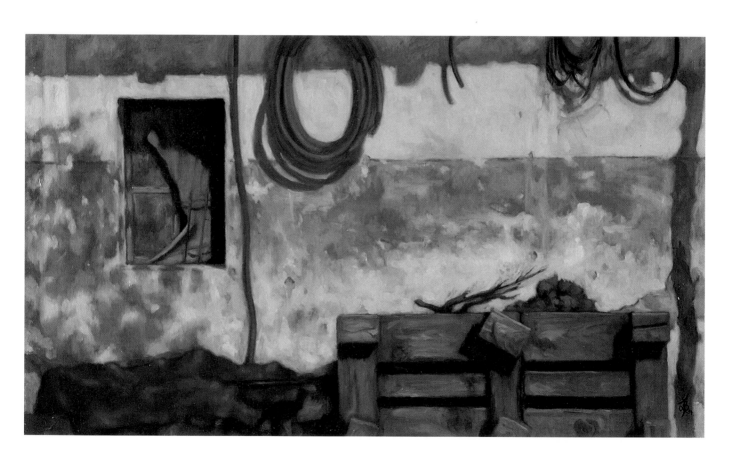

Figure 42
Farm Wall, Medjugorje
Oil

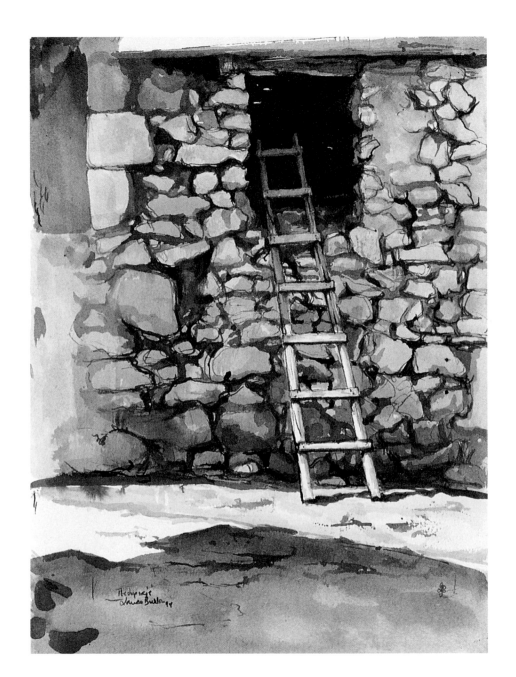

Figure 43

The Ladder

Sepia

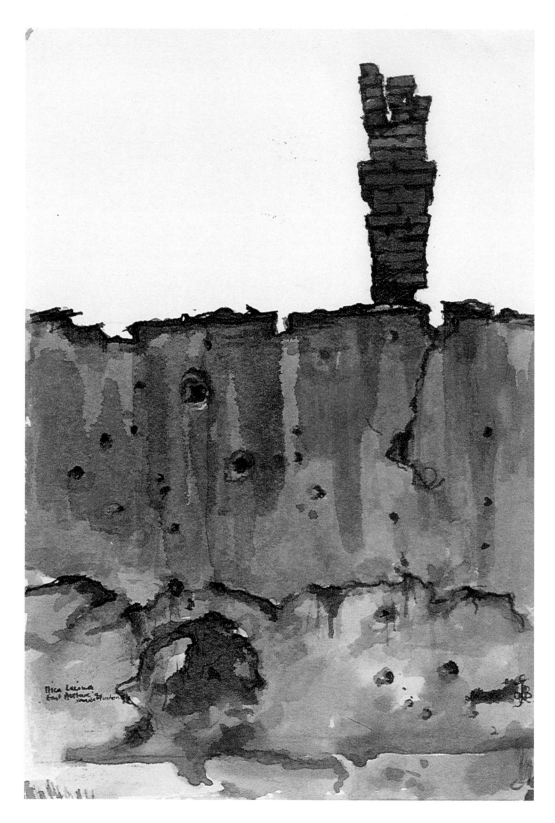

Figure 44

A Remaining Chimney Pot

Sepia

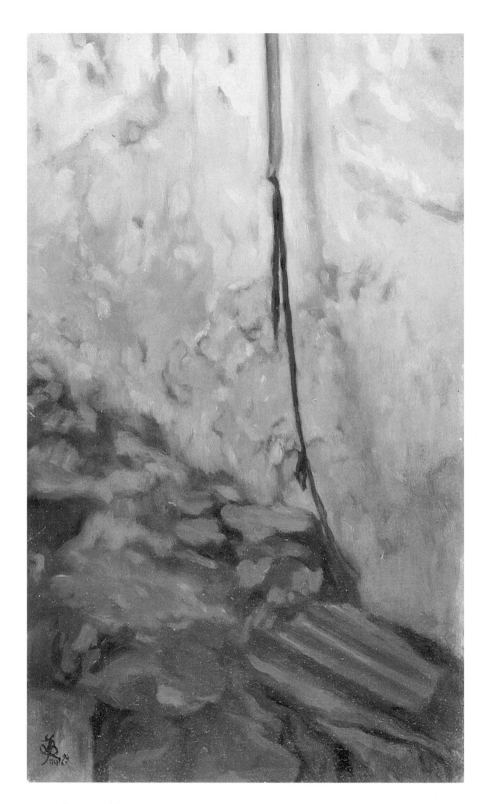

Figure 45
Red Ribbon

Sepia

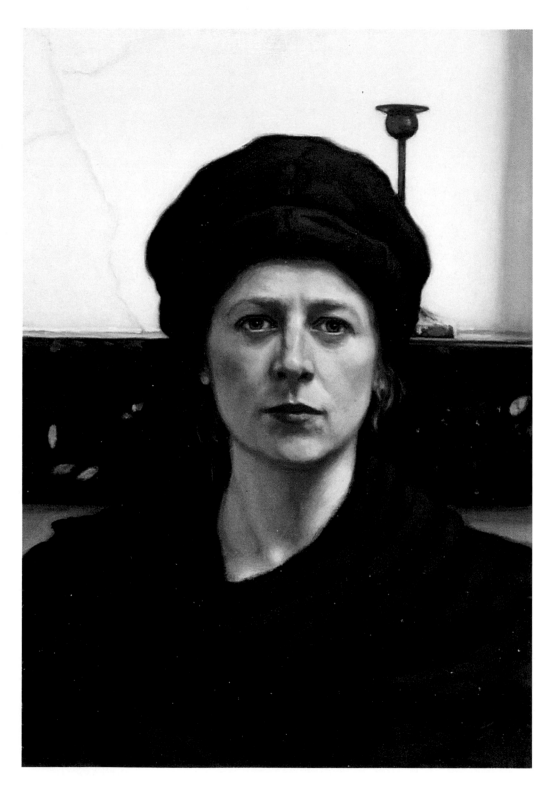

Figure 46
In Mourning
Oil

Part Five

A Portrait of the Artist in Time of War

Laura Buxton's self-portrait, *In Mourning* (fig. 46), evokes her thoughts at the conclusion of her first Balkan excursion. Like a Greek tragedian, her mask permits catharsis on the part of her audience, whose emotions and intellects have been wrenched by her presentation of the war against history.

Buxton was thirty-two when she first left Zagreb for Medjugorje. By then, Margaret Thatcher had issued her condemnation of the European community over what had been going on for the previous two years in Bosnia-Herzegovina. "I am ashamed of the European community," declared Mrs. Thatcher, "for this is happening in the heart of Europe. It is within Europe's sphere of influence. It should be within Europe's sphere of conscience. There is no conscience."

Her own conscience pricked, Buxton had planned to travel with a journalist friend on assignment from *Reader's Digest*, but at the last minute, the friend's plans changed. Alone in the Balkans, Buxton became a hitchhiker, tossing her boards and bag of painting gear into the backseats of little cars and answering questions in a polyglot of English, French, and Italian, picking up a smattering of Slavic as she drew closer to the war zone. The drivers' questions inevitably began with "*Koliko ste stari?*"—"How old are you?"—then moved to "*Gde je vaš muž? Gde su vam deca?*"—"Where is your husband? Where are your children?"

Initially, she planned to execute a few sketches of the places and the people she encountered, but when at last she reached Mostar, those plans

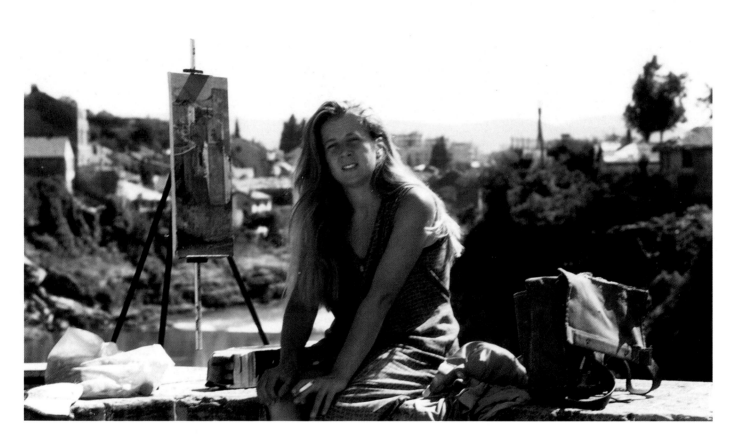

Figure 47
"At Stari Most"

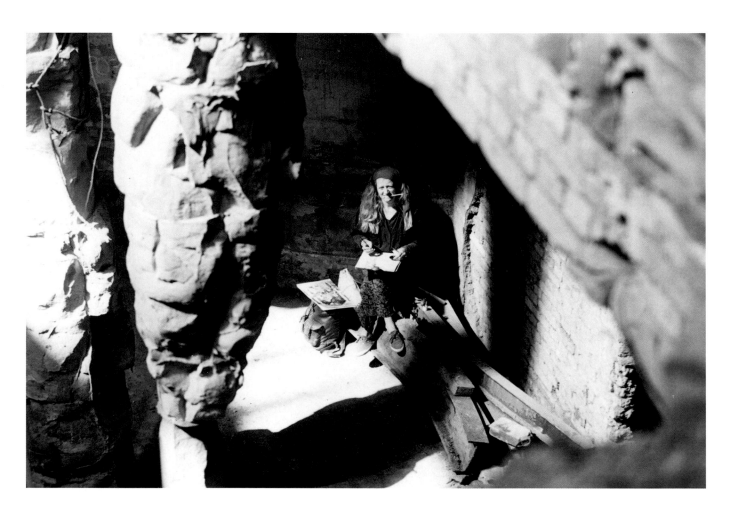

Figure 48
"In the National Library"

Reuters photo by Peter Andrews
Used by permission

changed. "Extremely depressed" by what she found, she ran headlong into her conscience. "I had to make a big decision. Either I would give up the whole idea of painting—which I came very close to doing, because I didn't think I was able to paint anything of consequence—and offer myself full-time to a relief agency, or else just let myself feel selfish and go on and paint. I chose the painting."

When she found a relief-agency representative who was making a short trip to Paris, she talked him into bringing back more canvases and paints. These allowed her to stretch an anticipated three-week visit into four months. She left only when the cease-fire collapsed and the shells began falling again on Mostar and Sarajevo.

Rather than sketching now and painting later, Buxton forced herself to complete on the scene as many works as circumstances permitted. She would select her subject, determine the best hours of day for light, then return to the same spot at the same time for as many days as it took to finish. On her second visit, she sketched evening scenes from her favorite table in a cafe that had risen from the rubble (figs. 49. 50). On the reverse of one of these sepias, she wrote: "This new cafe is on the street going up to the boulevard where the check-point was two years ago. The street has been cleaned up, but the view is principally the same. After a long day's work ended with the closing in of night, I came to this terrace for a drink before going home to draw."

She wasn't convinced that her work would mean anything to anyone. Ironically, it was the people around her, the people she left out of her paintings and drawings, who inspired her to go on. "They would always come around while I was working and say, '*Joj, što je lepo!*' which means, 'How beautiful!' I would walk out the door and people would shout, '*To je slikarka!*'—'It's the painter!'" Children thronged around her as though she were the Pied Piper, proclaiming beauty in a landscape of ugliness. "I felt a lot of appreciation from them, and I think that kept me going."

Sometimes, the crowds made it difficult to concentrate. She picked evening as the best time for painting *The Defeated Defender* (fig. 15) on the street leading to Tito's Bridge. She was pleased to see the customary crowd thin and then vanish as the sun went down, to be replaced by young soldiers assigned to night patrol of the still-dangerous front line. Even these soldiers seemed touched by her work, pulling up chairs and seats made from lumps of wreckage to sip thick coffee and critique her progress.

The mob of journalists, bearing video gear and irritating strobe lights, was the object of nonpartisan scorn, but the *slikarka* was a welcome diversion. "I was there among them every single day, week after week, not like those others, who would stuff cameras in their faces and barely say hello. I was an object of curiosity. I spent time with them, talked with them as much as was possible. It would have been more enriching if both sides had been able to understand more of what was said, but I

Figure 49
View from the Café—I:Mosque
Sepia

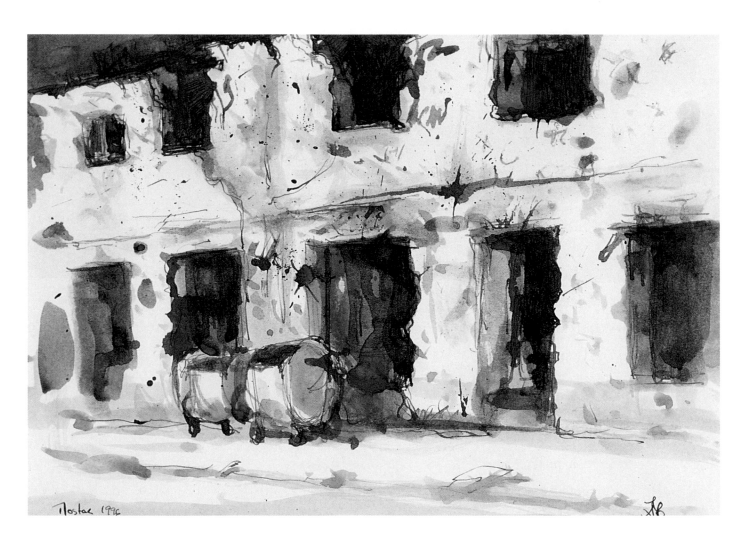

Figure 50
View from the Café—II: Dustbins
Sepia

think they honored me. On a very small level, I think I might have changed their scenery a bit."

The landscape of Buxton's own life returned to normal when she left Bosnia and went back to her home and studio in Paris in 1996.

Born in Scotland, she had studied in Florence before settling in France. Having successfully executed commissions from the British army (a painting of the Gulf War in 1991), the House of Commons, and Westminster Abbey, she began work in 1998 on a series of drawings of the construction of Britain's new Parliament Building in London, again a commission from the House of Commons. Her work has been exhibited in London's National Portrait Gallery, at the Institute de France, and at galleries in France, Great Britain, and the United States. While much of this work has been directed toward satisfying the artistic demands of great institutions, Laura Buxton continued a long tradition of art as social criticism in her Balkan paintings.

In contrast to twentieth-century artists who profited through their public disdain of the establishment, earlier painters were forced to take great pains in order to disguise their messages of protest. Botticelli's classic *Calumny*, painted one hundred years before the Ottoman Turks built Mostar's Stari Most, is believed by historians to be one such protest painting, either against the political attacks on Florence's first family (and Botticelli's patrons), the Medici, or else against the witch hunt that resulted in the immolation of the apocalyptic preacher Savonarola. But one cannot be absolutely certain.

The modern tradition of social criticism, especially the criticism of war, may have begun with Goya's *Executions of the Third of May* (1808). That distinguished antiwar line includes Marc Chagall's *Wounded Soldier* (1914), Picasso's *Guernica* (1937), and many of Diego Rivera's Mexican frescoes, such as *The Liberation of the Peon* (1931).

In most such works, however, the artist focuses our attention on the individual participants, attackers as well as victims, engaged in some military struggle. Buxton's decision not to include those individuals in her paintings seems almost to demand that we place *ourselves* within her ruined landscapes. She seems to ask that we confront not someone else's grief, but our own susceptibility to the wanton destruction of antiquity, and thereby to war in general.

In 1999, an international exhibition called "The Art of World War I" presented a remarkable collection of paintings done between 1914 and 1925. This exhibition of more than a hundred pieces by renowned artists from all over Europe and the United States depicted a war that started in this same Balkan region, in the very streets of Sarajevo. However, in the entire exhibition, only one work attempted to rivet the emotions and the intellect in the difficult, faceless way of Laura Buxton's landscapes. That painting, *L'église de Souain en silhouette* by Félix Vallotton, is a landscape of ruins in a delicate Japanese style, with trees and flowers emerging from a

demolished church. Vallotton's painting is not realistic, however, but symbolic—almost in the manner of Peter Blume's *Eternal City* (1937)—suggesting that nature is always victorious over the whims and wars of man. In a similar fashion, Dali gave us his *Paranoiac-Critical Solitude* (painted in 1935, the year before the start of the Spanish Civil War). In that work, flowers overwhelm the symbol of human achievement in the midst of a wasteland.

Unlike Dali, Blume, and Vallotton, Laura Buxton neither moralizes nor symbolizes; she simply presents the facts. It is up to us to draw our conclusions—to walk away unmoved or perhaps to shed a tear.

Understandably, it was the latter reaction that her paintings elicited from Sven Alkalaj, Bosnia-Herzegovina's ambassador to the United States, when he first viewed them at an exhibition in Washington. The ambassador addressed the crowd gathered at the opening to tell in a tremulous voice of the "strong impression" created by Buxton's work:

> As a Bosnian, I have seen these buildings in real life, and I must compliment the artist for her ability not just to paint the buildings and objects as they are, but also for allowing us to see the ghostly atmosphere that surrounds these architectural monuments. These melancholic paintings, of once-beautiful monuments that witnessed the horror of thousands of people killed and tortured, are seemingly people-less. But the voices and cries of victims of genocide are spread by the wind and echo through the deserted buildings, the voices of our dead. These buildings swallowed dozens of nationalist shells that were meant to destroy them as historical monuments and as testimonies to Bosnian, Muslim, Serb, Croat, and Jewish centuries-long peaceful coexistence. . . .
>
> Where are the people who used to sit in the cool shadow of a tree in Kujundžiluk and quietly sing love songs? Where are those people now? Most of them are gone. Some are exiled, and some will remain silent forever. Although people are gone, buildings remain as monuments of Bosnian multiculturalism. They speak for these silent victims of genocide. . . . The paintings themselves are the continuation of existence of the Bosnian heritage. And for that reason, I want to express the gratitude of my people and myself to Laura Buxton.

Perhaps with that expression of gratitude, Buxton could at last feel justified in her decision to draw and paint not the deeply wounded citizens of the Balkans but to depict instead their ruined landscapes.

LIST OF PAINTINGS WITH ACCOMPANYING TEXT

Part One Public Places

Figure	Title (medium)	Artist's Text
1.	*Stari Most* (oil)	"The famous old bridge survived invasions, battles and natural disasters over its four-hundred-year life. It took the Croatian army three goes to bring it down in a matter of minutes, to the horror of the Muslim and Croatian people alike. Even though broken, its beauty and magnitude shine."
2.	*Stari Most* (sepia)	
3.	*Approaching the Check-Point* (oil)	
4.	*A Break in the Frontline* (sepia)	
5.	*The Well in Use Again* (oil)	"This well served three generations of a family that came from different parts of Bosnia. Forced to take refuge somewhere, my friend Suzanna came with her parents to live with her grandparents in a tiny house in Medjugorje. While Suzanna worked as a translator, her mother and grandmother took care of her six-month old son, and they worked the land and the livestock. The little boy's father had been missing for a year. He eventually turned up, having spent two years in a prisoner of war camp. All the water that they could use came from this well."

Figure	Title (medium)	Artist's Text
6.	*Charred Remains of Town Hall* (oil)	"Unusually, I was alone while painting in the corridor of the first floor of this public building. What was left of the staircase was buried in several feet of ashes. The long, silent passages, burnt black, purple and blue, left the senses chilled."
7.	*Museum of Bosnia-Herzegovina* (oil)	"Another beautiful building on the bank of the river Neretva. Fortunately most of its collection was removed before it was so badly shelled. I sat on the opposite bank by the water to paint this. It was evening and tranquil after the hot days. The chimes of the bells beckoned the Catholic people to evening mass and the Mullahs called out their prayers. They agreeably resounded together down in the valley when all lived without hatred side by side. In the distance the dull thunder of the fighting continued on the front line three miles away."
8.	*Hotel Neretva* (sepia)	
9.	*Razvitak Department Store* (oil)	"Well targeted and collapsing symmetrically."
10.	*Previously a Bookshop* (oil)	
11.	*Bagna I* (sepia)	"This was built at the end of the Austrian-Hungarian administration, using influences of Oriental architectural design. Coloured stained glass was fitted in the dome and the rooms surrounding the bath were hand painted with arabesque patterns."
12.	*Tito Most* (oil)	"This was the replacement of the original Tito Most (Tito's Bridge), destroyed early on in the war. This one was semi-destroyed only one or two days after it was built by UNPROFOR, making it useless for anything but pedestrian traffic. It remained like this for over a year until the British battalion in UNPROFOR completely rebuilt it in

Figure	Title (medium)	Artist's Text

September of 1994. It was a symbolic day when it opened and vehicles were able to cross back and forth for the first time in three years."

13. *Vestiges of Stari Most* (sepia)

Part Two *Ratna Zona*: War Zone

14. *On the Boulevard: the Front Line* (oil)

"By the end of July they opened up the checkpoint on the boulevard between east and west, Muslim and Croatian Mostar. Between 7:00 A.M. and 7:00 P.M. women and children could cross. They could stay up to three days, although most seemed to do less. With families being separated for two years, this was very welcome, but permission and papers had to be obtained and that wasn't always so easy. I sat by the tent until 7:00 P.M. to paint this painting. All the while I listened to and saw the streams of women and children struggling with luggage filled to its limits with either food or some belongings. When they gave their name, number and address and had their papers stamped like convicts returning to prison, they did it with an accepting good humour that showed their wonderful courage in the face of adversity."

15. *The Defeated Defender* (oil)

"A BiH Armija truck from the east (Muslim) side of the frontline, looking toward the hills of the west. It was filled up with drums of petrol and rolled down the street at the advancing Croat army. The goal was to protect Tito Most (Tito's Bridge), but it was unclear whether it was successful. I heard varying stories. The street would empty while I was painting. It was evening and the only people to stay were the young soldiers-turned-policemen

Figure	Title (medium)	Artist's Text
		patrolling the frontline. They would bring up a few chairs around me and sit and watch, while chatting and drinking coffee."
16.	*The Defeated Defender* (inscription on reverse)	*The artist made notes on the backs of many of her canvases. She transferred this one to the paper backing of the frame.*
17.	*Frontline Barricade* (sepia)	
18.	*A Dead Yugo* (sepia)	
19.	*Jozo's Mercedes* (oil)	"During the worst periods of the war, the opening in the street was named 'Sniper's Alley.' The Mercedes probably brought protection to some during that time, then later became a playground for the children."
20.	*Tree on the Frontline* (sepia)	"Caught in the crossfire. A 'Pig in the Middle'—either East or West Mostar. Broken and splintered, like Bosnia's people."
21.	*Dr. Jazin's House After the Inferno* (oil)	"He told me that it burned for three days. He would come and talk to me as I was painting and tell me about the home he had and the life he lived within its walls."
22.	*Ulica Aleksa Šantic I* (sepia)	"This street was hidden behind the front line on the Croatian side in 1994. I had only seen it through a spy hole in one of the bunkers. This summer it was overgrowing with plant life."
23.	*Šantic II* (sepia)	"Aleksa Šantic was a very famous poet from the 19th and 20th century Mostar."
24.	*Šantic III* (sepia)	
25.	*War, Ulica Brace* (sepia)	"Just another ordinary person's modest home."

Figure	Title (medium)	Artist's Text

26.	*Bez Munare* (oil)	"During the evening while I was painting this piece, I would stand near one of the main street water pumps where people would come to get water for the night. As they went to fill their buckets, most of them would stop to see the development of the painting. One evening an argument broke out among the people watching me paint, so I asked for a translation. Some of the more religiously sensitive people thought that the minaret should be visible, but most thought it more apt to have left it out, showing just its shadow. The title *Bez Munare* means 'without minaret.'"
27.	*Gallery of Mehmed-Bey Karadoz Mosque* (oil)	"This is the largest and grandest of the twenty-some mosques in Mostar. It was built in 1557 during the reign of one of the greatest sultans, aptly called Suleiman the Magnificent. It was named after the vizier who oversaw the construction."
28.	*Tabačića Mosque* (sepia)	"This was drawn two years after my first visit. Built in 1600 in typical Turkish style of that period, making it difficult and costly to restore. The rooves of the epoch were made of thickly sliced stone, cut in the shape of a fan and layered one over the other. Highly decorative paint work, again in local colours, and inscriptions in Arabic are washed out but visible. Its minaret was one of only three that survived the bombardments, only to collapse in a storm earlier this year. It can be seen in the painting of the Kujundžiluk quarter."
29.	*Mir—Church of St. Peter and St. Paul* (sepia)	"'Mir' means peace. It was nailed to the wall with some of the fallen burnt beams. The priest kept flowers around the cross and altar and often held masses there for

Figure	Title (medium)	Artist's Text
		the few who remained in this 'zona rat' close to the front line."
30.	*Mir—Another View* (sepia)	"From the end of the 16th century until 1850, the Catholics did not have a church in Mostar. In the second half of this century it became a bishopric."
31.	*All That Remains of Orthodox Church* (oil)	"This Orthodox Church sits—or sat, rather—on the hill above East Mostar. Built in 18th or 19th Century, it sat in front of a small 14th Century Serbian chapel. The story of its destruction is mainly blamed on the insistence of the Serbian army to surround the church with their tanks, attack the town there. Obviously in the retaliation it got heavily damaged, but when the Četniks receded back over the hill, a large quantity of explosives was put in the building and it was exploded into a large pile of rubble. These door arches were the only thing that was vaguely recognizable."
32.	*Križevac* (oil)	"Cross Mountain, Medjugorje."
33.	*Sarajevo, a Muslim Cemetery* (sepia)	"Old Turkish-style tombstones mingle with new wooden name plaques."
34.	*Sarajevo National Library I* (sepia)	"The National Library was one of the first buildings destroyed in Sarajevo. Fortunately, a large part of its collection of books and archives was removed with great difficulty at the beginning of the siege. Only a shell remains, to remind us of its former grandeur, which was a highly intricate Austro-Hungarian architecture, based on Oriental design."
35.	*Sarajevo National Library II* (sepia)	"The temperature in the fire was so hot that the pillars splintered and crumbled."
36.	*Sarajevo National Library III* (sepia)	

Figure	Title (medium)	Artist's Text

Part Four A Sense of Walls

37. *Stari Grad—the Old Town* (oil)

"This is not the inside of a building left to ruin by disuse. It was a well-frequented café before the war, situated by the Stari Most until the war began in 1992. Twenty-five metres below these windows flows the river Neretva, with the shelled dome of the Koski Mehmed Pasha mosque (1618) on the opposite bank."

38. *Kujundžiluk Quarter* (oil)

"All the buildings are painted beautiful bright local colours, but according to one local person it was because in the past, when people couldn't read, each shop had its own colour so that people could identify them. Another local person said that in the sixties, when the old quarter was looking very run down, a local artist who had returned from teaching in Sarajevo decided to paint each building a different hue, in hopes of attracting tourists to the area. Kujundžiluk are master craftsmen in metalwork (mainly in copper), and this is the quarter that they have always worked in, hence its name."

39. *Bolnica Rat* (oil)

"This was the old hospital of Mostar that was used as a clinic before the war because of its limited resources. A new, modern hospital was built on the west side of Mostar, but when the war broke out the Muslims on the east side had to use the old hospital as a place for their wounded and dying."

40. *War Hospital Window* (oil)

41. *View of the Hume from Pasha's Balcony* (oil)

"The hill Hume hangs ominously over Mostar. Its beauty came to represent threat. From there the H.V.O. (Croatian-

Figure	Title (medium)	Artist's Text
		Herzegovinan Army) attacked East Mostar relentlessly for two years."
42.	*Farm Wall, Medjugorje* (oil)	
43.	*The Ladder* (sepia)	"After several weeks in East Mostar, I returned to Medjugorje and to the freshness of the countryside for a couple of days. The ladder's rungs begin in the sunlight and advance into the darkness. Briefly it seemed to say something about the current situation in this country."
44.	*A Remaining Chimney Pot* (sepia)	
45.	*Red Ribbon* (oil)	"My last painting in Mostar."

Part Five A Portrait of the Artist in Time of War

Figure	Title (medium)	Artist's Text
46.	*In Mourning* (oil)	
47.	"At Stari Most" (photo)	*Buxton pauses for a snapshot by a friend as her oil painting of the Old Bridge nears completion.*
48.	"In the National Library" (photo)	*Reuters photographer Peter Andrews captured the artist at work in the Sarajevo National Library in 1996 (see figs. 34–36). His photos ran in a number of European newspapers.*
49.	*View from the Café I: Mosque* (sepia)	"This new café is on the street going up to the boulevard where the checkpoint was two years ago. The street has been cleaned up, but the view is principally the same. After a long day's work ended with the closing in of night, I came to this terrace for a drink before going home to draw."
50.	*View from the Café II: Dustbins* (sepia)	"Same café, another evening, a different view."

SELECT BIBLIOGRAPHY

Benac, Alojz and Ivan Lovrenovic. *Bosnia and Herzegovina.* Belgrade: Igkro "Svjetlost" Jugoslovenska Revija, 1980.

Cultural Institutions and Monuments in Sarajevo. Sarajevo: National and University Library of Bosnia-Herzegovina, 1995.

Glenny, Misha. *The Fall of Yugoslavia: The Third Balkan War.* New York: Penguin, 1992.

Maas, Peter. *Love Thy Neighbor: A Story of War.* New York: Knopf, 1996.

Recknagel, Charles. *Reconstructing Mostar*, a series on Radio Free Europe. March-April 1996. For text see http://www.rferl.org/nca/special/mostar.

Testimony presented before the Commission on Security and Cooperation in Europe, April 1995. Portions of testimony available at http://www.haverford.edu/relg/sells/killing.

Vulliamy, Ed. *Seasons in Hell: Understanding Bosnia's War.* New York: St. Martin's Press, 1994.

ACKNOWLEDGMENTS

In addition to the McColl Collection, Ms. Buxton's Balkan paintings are in the collections of Marcel Ballot, Jurčić Berislav, Christopher Buxton, Lady Cubitt, Kumar Datwani, Countess of Elgin, Fenella Foster, Louis Grieg, H. Koschnick, Cornelia Leiske, Rosie De Sales La Terriere, Johan Ventor, and Peter Wilson. The artist wishes to thank each of these individuals for their support and for allowing the works to be presented here.

The works were photographed by Philippe Galard (Paris) and Ric Starling (Charlotte).

The author is grateful for the kind assistance of several experts in the area of Bosnian culture and language. Among these are Mostar-born writer Radmila Johnson of Charlotte, Dr. Marian Wenzel and Amra Abadzic of the Bosnia-Herzegovina Heritage Relief Organization, Andras Riedlmayer of the Harvard University Fine Arts Library, and John Kozlich, whose Mostar website (mostar@tyenet.com) provided a wealth of information. At John F. Blair, Publisher, the contributions of editor Steve Kirk and designer Debra Hampton were invaluable.

Ottoman Empire, vii, 5, 28, 37, 38, 41, 46, 54, 61

papak, 61
Paris, France, 3, 21, 73
Pasha, 57
Pašić, Amir, 57
Passover, 46
Picasso, Pablo, 73

raja, 62
ratna zona, 21, 27
Reader's Digest, 67
Riedlmayer, Andras, 28
Rivera, Diego, 73
Roman Catholic Church, vii, 5, 10, 22, 27, 28, 37, 41, 46, 76, 80
Roman Empire, 5
Rome, Italy, 38

sadrvan, 38
Šantic, Aleksa, 27, 78
Sarajevo, 5, 10, 37, 46, 61, 70, 73
Sephardim, 46
Serbs, 4, 10, 17, 21, 27, 28, 38, 41, 46
sevdalinke, 53
Shakespeare, William, 5
Slavic (language), 4, 21, 41, 57, 67
slikarka, 4, 21, 70
sljivovic, 54

Slovenia, 21
Sniper's Alley, 27, 78
Spain, 46
St. James Church, 46
St. Paul Church, 41
St. Peter Church, 41
Stari Most (Old Bridge), 4, 5, 6, 17, 22, 28, 54, 73, 75, 81
Suleiman the Magnificent, 5, 79

Tabačića. *See* Hadzi-Kurto Mosque
Taj Mahal, 53
Talmud, 46
Thatcher, Margaret, 67
Tito, Marshal Josip, 10, 17, 22, 27, 76

University of Sarajevo, 52

Vallotton, Felix, 73-74
Viječnica, 46, 52
Voyvodina, 21

Washington, D.C., viii

Yugoslav People's Army, 17, 38
Yugoslavia, 6, 17, 21, 61

Zagreb, 67